La France
Images of Woman and Ideas of Nation 1789-1989

Hayward Gallery London
26 January to 16 April

Walker Art Gallery Liverpool
3 May to 11 June

South Bank Centre 1989

Exhibition organised within the framework of the cultural exchange programme between France and Great Britain under the auspices of the Ministère des Affaires Etrangères, Secrétariat d'Etat chargé des Relations Culturelles Internationales, and the Ministère de la Culture, de la Communication, des Grands Travaux et du Bicentenaire de la République Française, by l'Association Française d'Action Artistique and the South Bank Centre.

This exhibition forms part of the South Bank Centre season Revolution-Revisited: a Celebration of France

REVOLUTION·REVISITED
a celebration of France

Cover illustration:
François Jouffroy
Nymph personifying the River Seine
From an original of 1865, near St-Seine-l'Abbaye.
Photo: Dorothy Bohm.

The naiad presides in a grotto 10 km. to the N-W of St-Seine-l'Abbaye, near to the N.71 running N-W from Dijon. A gallo-roman temple site and cult-remains nearby point to an early feeling for the place. Jouffroy ran one of the main teaching ateliers of the 1860s, at which he turned up infrequently and said little (See *La Sculpture Française au XIX*ᵉ *siècle*, Paris 1986, p. 41).

Comité d'Honneur

M. Roland Dumas
Ministre d'Etat, Ministre des Affaires Etrangères

M. Jack Lang
Ministre de la Culture, de la Communication, des Grands Travaux et du Bicentenaire

M. Thierry de Beaucé
Secrétaire d'Etat auprès du Ministre d'Etat, Ministre des Affaires Etrangères, Chargé des Relations Culturelles Internationales

Son. Exc. M. Luc de la Barre de Nanteuil
Ambassadeur de France en Grande-Bretagne

Comité d'Organisation

M. Louis Joxe
Ambassadeur de France, Président de l'Association Française d'Action Artistique

M. Jean-Noël Jeanneney
Président de la Mission du Bicentenaire de la Révolution Française et de la Declaration des Droits de l'Homme et du Citoyen

M. Jean-Pierre Angremy
Directeur Général des Relations Culturelles, Scientifiques et Techniques au Ministère des Affaires Etrangères

M. Olivier Chevrillon
Directeur des Musées de France

M. Jean Maheu
Président du Centre Georges Pompidou

M. Jean-Hubert Martin
Directeur du Musée National d'Art Moderne, Centre Georges Pompidou

M. André Zavriew
Sous-Directeur des Echanges Artistiques et Culturels au Ministère des Affaires Etrangères, Directeur de l'Association Française d'Action Artistique

M. Philippe Guillemin
Conseiller Culturel près l'Ambassade de France en Grande-Bretagne

Commissariat

Mme Isabelle Julia
Conservateur des Musées de France à l'Inspection Générale des Musées Classés et Controlés, Conservateur du Musée Hubert

M. Alain Sayag
Conservateur du Musée d'Art Moderne, Centre Georges Pompidou

M.Max Moulin
Chargé de l'Europe de l'Ouest au Bureau des Arts Plastiques, Association Française d'Action Artistique

Si de nombreuses manifestations artistiques marqueront, partout dans le monde, le bicentenaire de la Révolution Française, l'exposition réalisée à l'initiative de Madame Joanna Drew et de Monsieur Ian Jeffrey à Londres et Liverpool se signale, me semble-t-il, par son originalité.

Loin de limiter à la période révolutionnaire le choix des oeuvres qu'il s'est appliqué à rassembler, le commissaire Britannique a conçu le projet d'étudier la naissance et l'évolution du concept de nation, depuis 1789 jusqu' à nos jours, en présentant des images que nos artistes ont données de la femme. Qu'elle illustre explicitement la revendication nationale ou qu'elle se contente de refléter, à travers les bouleversements de l'histoire, la lente recherche d'une identité, la figuration féminine témoigne en effet des grands thèmes qui hantent l'imaginaire française de l'époque. Ainsi à travers les portraits de 'Marianne' ou de 'Kiki de Montparnasse', de la 'Femme de Gréviste' ou de 'Ruth' - à travers des représentations réalistes, mythiques ou symboliques - le public Britannique pourra découvrir deux siècles de réalités sociales reflétées par nos peintres, nos sculpteurs, nos graveurs et nos photographes.

Le Musée National d'Art Moderne, les Musées du Louvre, d'Orsay et de la Ville de Paris comme de très nombreux musées de province - Lyon, Rouen, Poitiers, Moulins, Troyes, etc... comme les Musées de Leeds et Glasgow, le British Museum, la National Gallery, le Victoria and Albert Museum - ont répondu avec enthousiasme aux demandes de prêt de nos deux commissaires Français, Mme Isabelle Julia et M. Alain Sayag et je tiens à remercier les municipalités et leurs conservateurs pour leur généreux concours à cette exposition.

Puisse cette patiente et fructueuse collaboration entre les scientifiques de nos deux pays trouve, auprès des visiteurs, l'accueil qu'elle mérite.

Thierry de Beaucé
Secrétaire d'Etat auprès du Ministre d'Etat, Ministre des Affaires Etrangères, chargé des Relations Culturelles Internationales

This exhibition forms part of the South Bank Centre's season to mark the bicentenary of the French Revolution. It has been organised in collaboration with the Association Française d'Action Artistique and we would like to record our gratitude to our French colleagues who have so readily provided support and practical assistance; in particular to M. André Zavriew, Director, Pascal Bonafoux and Yves Mabin, formerly in charge of the Bureau des Arts Plastiques, and Max Moulin who has been responsible for the administration of the exhibition in France. We have, as on many occasions in the past, received welcome advice and assistance from the French Embassy in London and would like to thank in particular M. Philippe Guillemin, Conseiller Culturel and M. Patrick Vittet-Philippe, Attaché Culturel.

The concept for the exhibition is that of Ian Jeffrey who has travelled widely in France and visited many regional collections in making his selection of works. The subject is too vast to be encompassed in the scale of the present exhibition, which stands in the relation of a sketch to a large 'finished' work.

Ian Jeffrey's original selection has been augmented and modified by the proposals of Isabelle Julia and Alain Sayag, appointed as the French 'commissaires' for the exhibition for the nineteenth and twentieth centuries respectively. We are warmly grateful for their participation in the realisation of the exhibition and this catalogue.

Thanks are also due to the following: Ghislaine and Rémy Bernard, Dorothy Bohm, David Britt, Mark Hedger, Segolène le Men, Tim Pember, Brendan Prendeville and Muriel Walker.

Finally we are extremely grateful to the many museums and private collectors in France and Britain who have generously lent works for the exhibition and whose names are listed on pages 5 and 6.

Joanna Drew
Director, Hayward and Regional Exhibitions

5

Lenders to the exhibition

France

Arras, Musée d': 31
Beauvais, Musée départemental de l'Oise: 44
Bordeaux, Archives Municipales de: 65
 Musée des Beaux Arts: 141
Boulogne-Billancourt, Musée de: 57
Brest, Musée des Beaux Arts: 43
Calais, Musée des Beaux Arts et de la Dentelle: 130
Louis Cane: 32
Henri Cartier-Bresson: 36
Dijon, Musée des Beaux Arts: 108, 121, 124
Robert Doisneau: 59, 60, 61
Gray, Musée Baron Martin: 132
Grenoble, Musée de Peinture et de Sculpture: 14, 29
La Rochelle, Musée d'Orbigny-Bernon: 153, 154, 155, 156
 Musée des Beaux Arts: 39, 52
Le Havre, Musée des Beaux Arts André Malraux: 63, 64, 120
Lyon, Musée des Beaux Arts: 33, 67, 122
Annette Messager: 112
Jean-Yves Mock: 99
Mont-de-Marsan, Musée Despiau-Wlerick: 116, 152
Moulins, Musée d'Art et d'Archéologie: 84, 107
Nantes, Musée des Beaux Arts: 42, 117
Orléans, Musée des Beaux Arts: 90
Paris, Musée Henri Bouchard: 21
 Musée Bourdelle: 23
 Musée Carnavalet: 97
 Casterman Publishers: 143
 Bibliothèque du Musée de la Comédie Française: 4
 Galerie Michel Chomette: 123
 Musée Nationale d'Art Moderne, Centre Georges Pompidou: 6, 20, 24, 25, 26,
 28, 55, 56, 58, 62, 69, 88, 91, 94, 101, 102, 105, 109, 119
 Musée Gustave Moreau: 115
 Musée d'Art Moderne de la Ville de Paris: 75, 134, 135
 Musée d'Orsay: 16, 17, 35, 66, 111, 127
 Musée de l'Orangerie: 110

Lenders to the exhibition

Musée du Louvre: 41, 48, 49, 91
Musée National des Arts et Traditions Populaires: 2, 3, 157, 158
Musée Rodin: 129
Poitiers, Musée de la Ville et de la Société des Antiquaires de l'Ouest: 19, 151
Quimper, Musée des Beaux Arts: 11, 12
Mme Reiser: 125
Rennes, Musée de Bretagne: 13, 89
Denis Rivière: 128
Willy Ronis: 133
Rouen, Musée des Beaux Arts et d'Archéologie: 47, 150
Jean Rustin: 139
Saintes, Musée des Beaux Arts: 82
St. Etienne, Musée d'Art Moderne: 103
Ivan Theimer: 148, 149
Troyes, Musée des Beaux Arts: 85
 Musée d'Art Moderne: 37
Valenciennes, Musée des Beaux Arts: 87
Vesoul, Musée Georges Garrett: 83

United Kingdom

Bath, The Royal Photographic Society: 50, 51, 71, 72, 73
Glasgow, The Burrell Collection, Glasgow Museums and Art Galleries: 45, 46
Leeds, City Art Gallery: 18
London, The Trustees of the British Museum: 1, 5, 10, 30, 34, 70, 86, 96, 100,
 131, 138, 140
 The Trustees, The National Gallery: 15
 The Board of Trustees of the Victoria and Albert Museum: 7, 8, 38, 74, 76, 77, 78,
 79, 92, 93, 113, 118, 136, 137, 144, 145, 146, 147

and private collections

7

Contents

Introduction by Ian Jeffrey **8**

 A Sentimental Education/Household deities/Françoise/
 Tragedy and Beauty/Moments/Modernism/Inwardness/
 La femme fatale/Nation/Post-modernist fragments/
 Survivals

The Survival of the Genres by Alain Sayag **82**

Daughters of the Century by Isabelle Julia **86**

Plates **97**

List of works in the exhibition **129**

A Sentimental Education

Ian Jeffrey

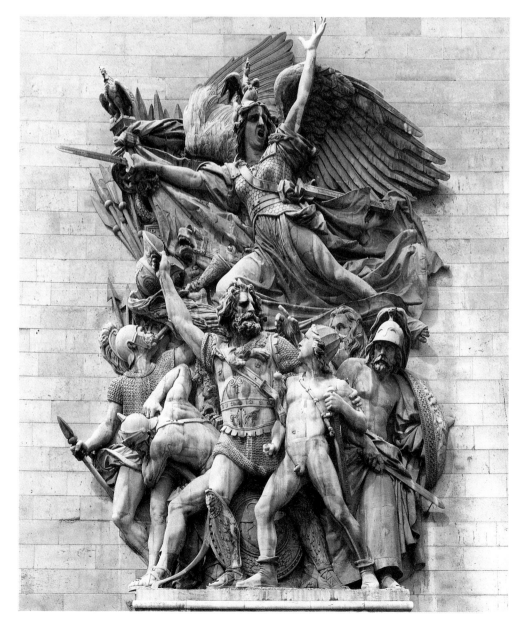

François Rude
*Departure of the
Volunteers*, 1792
Arc de Triomphe,
Paris
Not in exhibition

From the west face of
the Arc de Triomphe de
l'Etoile. Rude, who had
strong Bonapartist
sympathies, spent from
Waterloo to '27 in
Belgium. He began work
on the Arc de Triomphe
in '29, and in 1830 was
asked to complete the
entire programme,
although this was
successfully protested.
Originally the scheme
was meant to celebrate
imperial victories in
Egypt and Spain, but the
July Monarchy muted
the Napoleonic side of
things and Louis
Philippe pressed for
gallic cocks at the
expense of imperial
eagles. Unveiled in 1836.

The people distressed

The French Revolution of 1789 marked a new beginning in the history of the world, and seemed set to put a stop to tyranny everywhere. Looking back in 1846, Jules Michelet, the great historian and narrator of France, wrote in his preface to *Le peuple*:

> Frenchmen of every circumstance, of every class and of every party, remember one thing, you have on this earth only one true friend and that friend is France. You will always be guilty, in the eyes of the eternal coalition of aristocracies, of one crime, of having, fifty years ago, sought to deliver the world. They have not forgiven it, they will not forgive it . . . In the eyes of Europe, let it be known, France will always have but one inexpiable name, which is her true name in eternity: the Revolution.[1]

An inheritance to be proud of, but one which raised a surplus of awkward questions. If France was the homeland of republicanism and of liberty, and had 'sought to deliver the world', and if it constituted a unity, unique in Europe, of a sovereign people at home in its own land, how were political failures and military disasters to be explained? The history of France after the Revolution was, inevitably, a history of shortcomings, of disappointments and of explanations. Governments may have become unrepresentative and corrupt, and the people become degenerate, but, somewhere within, France survived . . . if only the corruption could be stripped away. There grew up myths of France and of its people, myths designed both to celebrate the grandeur of the idea, and also to excuse and to justify. *La France*, 'the one true friend' cited by Michelet, was a mother and her children, marching to war against tyranny, were the people, aggressive and masculine. That, at least, is how it goes in Rouget de Lisle's *La Marseillaise* of 1792.

The people, at the outset, were in the right and they were inexorable: 'Le peuple souverain s'avance, Tyrans, descendez au cercueil.'[2] The day of glory had arrived, and the bloody standard of the tyrants was unfurled in opposition. It stayed unfurled and presided over the first great representation of the people in distress, Géricault's *Raft of the Medusa*, shown in the Salon of 1819. Controversy cost Géricault a medal, to his annoyance, for he may not have meant the *Raft* as it was taken. Survivors of a shipwreck, men deserted by their officers, make signals from their makeshift raft with white cloths, one of them stained with blood. The flag of the Monarchy was white, in opposition to the tricolour of the Republic, which made it difficult to resist the idea

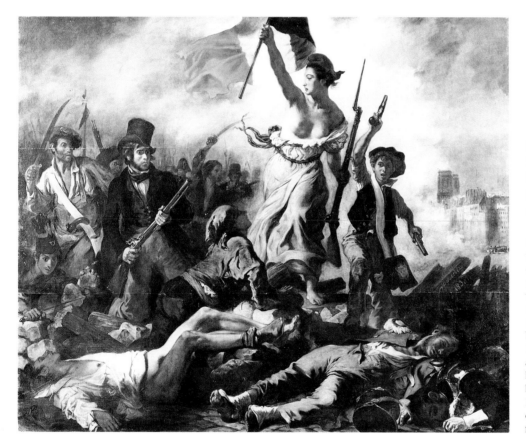

Eugène Delacroix
*Liberty guiding the
People*, 1830
Musée du Louvre
Not in exhibition

Known to Delacroix as
the *28 Juillet* or the *Liberté*
or the *Barricade* this
painting celebrates the
three glorious July days
in the Revolution of
1830. It was painted
between October and
December in that year,
and put the painter 'en
belle humeur'. Bought
by the state in 1831,
Liberté was only shown
on a permanent basis
from 1863.

that the scene represented the people abandoned. Cannibalism too is admitted in a dismembered corpse, easily taken to represent a nation at war within itself. The body most clearly displayed in the arrangement lies with thighs spread to disclose genitals, now useless in death. The same gesture recurs reversed to the right, with the addition of a drapery, as if the artist wanted to articulate and to emphasise a difference, to bring it into discussion. Michelet, lecturing in 1845, adjudged Géricault the first properly French painter, at one with the nation and with the thought of the people. The *Raft* was a portrait of France entering the tomb.[3]

In 1830 Delacroix might have had some of Géricault's casualties in mind in *Liberty Guiding the People,* for another matching pair of dead men lie to our side of the barricade, one clothed and the other stripped. Delacroix was always studious, purposeful and deliberate in his arrangements, and that opposition of masculine thighs looks symmetrical enough to read in terms of death as impotence. The people themselves, represented by a lightweight student in a floppy hat, a roughneck man-of-the-people in a beret, and a modish musketeer in a topper, look both spirited and vulnerable, like irregulars who might not see the day through. A few years later, though, they would be pulled together by François Rude for the *Departure of the Volunteers* 1792, his sculpture for the Arc de Triomphe, where it was installed in 1836. His people, six of them, set off in Roman fighting gear under 'RF', the initials of the Republic. The main man is rather to the Mosaic side of his prime, and as martial as he is responsible, and the nude youth by his side might be his son, or a brother to Delacroix's student. In Rude's earlier thoughts, in plaster in the museum in Dijon, man and youth are both nude, both vulnerable among all that promise of sword-play. In the finished ensemble it is the boy alone, as if to emphasise human fragility itself. Overhead the spirit of war indicates the enemy and cries to other people beyond. Her force of character meant that the *Departure* became, unofficially but assuredly, *La Marseillaise.* Neither artist minimises the force and beauty of the idea, but, on the other hand, neither understates the risks involved. If Géricault's survivors represent France entering the tomb, these show her, or at least her people, undertaking a potentially fatal mission.

Man as monster

For a very short period after the Revolution there was a movement to represent 'The People' as triumphantly masculine. In July 1793 (Messidor, *an* I), Jacques Louis David proposed for the 'Fête de l'Unité et de l'Indivisibilité' a giant statue of the French People, to be sited on a mountain top on the Place des Invalides. In November 1793 (Brumaire, *an* II), he recommended something similar for the Place du Pont-Neuf, and the Convention specified that it should be in bronze, forty-six feet in height, carrying figures of Liberty and Equality in one hand and a club in the other. Bronze proved impossible, but in various celebrations of 1793-4 a giant of sorts did appear, in more

perishable material, with its left foot placed on the neck of a counter-revolutionary creature, half-woman, half-serpent. It was variously misread by contemporaries as Hercules or as a menacing monster. Then in an idea for *Le Triomphe du peuple français* David imagined another armed giant, seated in a chariot drawn by bulls, with Liberty and Equality on his knees. The Revolution was an exciting and virile time, worthy of Hercules with his club, but he seems not to have answered to a need in the public imagination. He was, after all, an associate of emperors and of tyrants, against which the Revolution inveighed. He was, in addition, a man involved in a drama imagined by men, and as such hardly the stuff of which their dreams were likely to be made. *La Marseillaise* (originally the *Marche des Marseillois*) fitted far better, with its image of the 'enfans de la Patrie' confronted by the roaring of ferocious soldiers, yet brought to victory in the end by 'Liberté, Liberté chérie.' The omnipotent Hercules lacked pathos, made no allowance for the sufferings involved in revolution.[4]

Man, born to suffer, continued to represent the people in trying times. David himself quickly realised that the public imagination warmed to pathos rather than to heroism, and in 1794 painted the martyrdom of Joseph Bara, a thirteen-year-old drummer boy shot by Royalist troops when he replied 'Vive la République!' to their demand that he should proclaim the King. The naked child expires delicately in an unforgiving, and unfinished, desertscape. If Hercules is awesome, beyond compare, the drummer boy is frail, even exquisite. David's imagination moved between the kind of extremes which mark *La Marseillaise*, with its range of young sacrificial citizen-heroes who are at the same time magnanimous warriors capable of coping with parricidal tyrants and monsters.[5]

Man perplexed

Men, as heroes or victims, could stand, in this economy of images, for the people triumphant or afflicted. To a radical idealist Man might be associated with Hercules or Christ, as David suggested in the figure of the murdered Marat, but to those authorities who were to keep the records (Balzac, Stendhal, Flaubert, Proust) he featured increasingly as a more-or-less shabby customer, a prey to uncertainties and sordid cravings, and no fit match for La Patrie, La Liberté, La République, supplemented from around 1850 by the irresistible Marianne. He was an immoderate

figure and, in the end, compromising.

The image of Man inherited from the Ancien Régime ran to extremes. On the one hand there was the unbelievable grandeur of the Sun King, expressed in, for instance, *Louis XIV admiré par l'univers*, by Pierre Monier, now keeping humbler company in the Musée des Hôpitaux de Paris. And on the other there was the courtier, never his own man in circumstances where he was obliged to scheme and to entertain to keep or to win a place. Denis Diderot found a virtuoso among these in the shape of Rameau's nephew entertaining in the Café de la Régence, Place du Palais-Royal. The nephew, who would become a famous symptomatic man in cultural history, could mouth an orchestra of instruments, sing all the parts, shape his face to scorn, disdain and irony, and speak with love or anger according to need. The truth escapes him, as it escapes the philosopher with whom he talked, and who stresses the distance between words sanctioned by usage and the vague ideas which lie beyond. Written in 1761, Diderot's text was first published in 1805. Its affinities were with the new age, and the nephew himself, often on his uppers although stylish to the end, might have seen service as supporting cast on Delacroix's barricades in 1830. Certainly Liberty herself would have won his heart, for the discussion in the Café de la Régence ends with a sobbing recollection of an exemplary ideal woman, now long gone, carefree, beautiful, admired, intelligent and wise. She enters at the last and almost out of the blue, for an earlier appearance would have upstaged the rest of a performance marked by extremes of worldly wisdom.[6]

Rameau's nephew, would-be artist and intermittently successful socialite, might have been the model for all those failures who occupy centre-stage in the literature of the nineteenth century: Proust's Marcel, for example, always on the point of putting pen to paper (eventually doing so over nine books and three thousand pages), and in love beyond his reach, either with a haloed name such as that of the Duchesse de Guermantes or with the falsehood incarnate of Albertine. Flaubert's Frédéric Moreau, in *Sentimental Education*, means well too, as the Walter Scott of France, as a poet, composer of German waltzes, and then as a painter, a role assumed to take him closer to the woman he loved: Mme Arnoux, as remote as anyone imagined by Marcel. Frédéric, rich in failed intentions and dependent on inheritances, exists as a space in which society might display itself. He is by no means the worst of the men paraded by

Flaubert, who was fascinated by opportunistic office-holders such as M. Dambreuse, who had 'acclaimed Napoleon, the Cossacks, Louis XVIII, 1830, the workers, truckling to every government, worshipping Authority so fervently that he would have paid for the privilege of selling himself.'[7] M. Dambreuse is one of a type who 'would have sold France or the whole human race to safeguard their fortune, to spare themselves the slightest feeling of discomfort or embarrassment, or even out of mere servility and instinctive worship of strength.'[8] They scheme, Flaubert's men, for the sake of power and money, or for no reason other than predatory instinct: Dambreuse, again, with 'a pitiless energy . . . in his grey-green eyes'. His true man of the people, Dussardier, may be a hero but he is also a simpleton. The ideologue and revolutionary, Sénécal, shows authoritarian tendencies throughout. M. Arnoux, philanderer, national guardsman and time and again a failed entrepreneur, turns out a hero of sorts in the Revolution of 1848, but almost casually. Flaubert's men are hesitant, either because nature made them so or because society is unfathomable, moved by obscure forces or guided by mere slogans. Politics, in *Sentimental Education*, is a matter of phrases, deployed by a writer who was a connoisseur of cliché; and posture and appearance, too, were learnt from the great generation of Saint-Just, Danton, Marat, Blanqui and Robespierre. The Revolution of '48 was, as described by Flaubert, a performance rehearsed, but imperfectly remembered.

Absent authority

The modern age, as manifest in post-revolutionary France, was never other than anxious and doubtful with respect to authority. Where did authority now rest? Only in phrases, if Flaubert was to be believed. God comes up in his *Dictionnaire des idées reçues*, between 'Dictionnaire des Rimes' and 'Dilettante', as formulated in the Enlightenment: 'Voltaire lui-même l'a dit: "Si Dieu n' existait pas, il faudrait l'inventer".' And he has Sénécal invoke the People, with respect to university degrees: 'Let us keep them, but let them be conferred by universal suffrage, by the People, the only true judge.'[9] Authority rested in ideas become slogans or commonplaces exchanged in salons, in workplaces and in the street. Flaubert's theme is authority and its absence. God has been disposed of by Voltaire and by loose talk. The people are either as naïve as Dussardier or brutish and fickle, marauders rather than 'the only true

A Sentimental Education

Théodore Géricault
The Raft of the Medusa,
1819
Musée du Louvre
Not in exhibition

Géricault and the *Raft*
toured England in 1820.

judge'. The more impressionable of the middle classes believe in honours and in phrases, and they are magnificently represented by the chemist Homais in Flaubert's *Madame Bovary*. The more prudent, even someone as hard-headed as the bailiff Roque in *Sentimental Education*, have a superstitious regard for birth and for its titles, but there too there are no certainties, as Flaubert is at pains to demonstrate. Proust would later go over much the same ground, especially with regard to family names often more invented than inherited. The only civil certainties represented in the *Education* involve

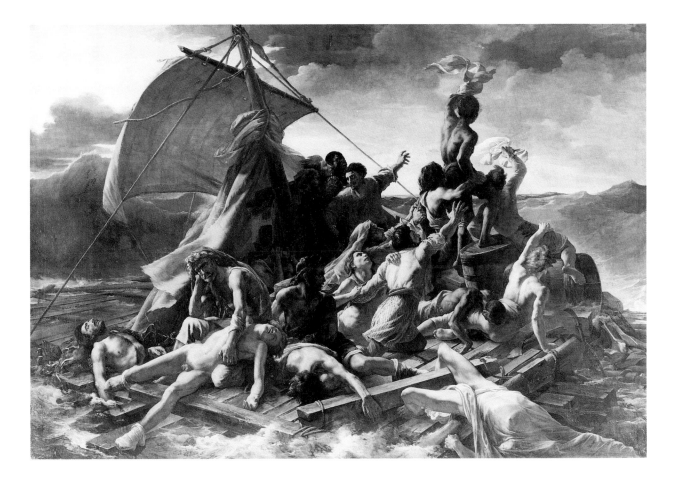

M. Dambreuse with his 'pitiless energy'; without that animal, and inexplicable, quality, Flaubert's characters drift; Frédéric comes to know 'the melancholy of the steamboat, the cold awakening in the tent, the tedium of landscapes and ruins, the bitterness of interrupted friendships'.[10]

Sentimental Education, completed in 1869, constitutes, with its cast of opportunists and betrayers moved by greed, lust and primitive instinct, an allegory of the modern.

Thirty years before, Stendhal's account of the same problem had been published as *The Charterhouse of Parma*. Both projected history as bafflement: for Flaubert it was the Revolution of 1848, and for Stendhal the Battle of Waterloo, so shapeless and inconclusive that his hero, Fabrizio, came eventually to wonder if he had ever been present. Thus history, which might have shown some logic of its own, was introduced as pure contingency. Escaped from chaos, Fabrizio arrives in Parma which has a king, Ranuccio-Ernesto IV, and a prime minister, Conte Mosca, opposed by other politicians almost as important as himself. The king, seeking election to the kingship of a united Italy, acts with circumspection or as just another politician serving his own interests. Fabrizio, often a victim of circumstance and impulse, becomes a churchman, despite his secular and self-indulgent life-style. Having fallen hopelessly in love he turns to preaching, and Stendhal shows him as a great performer and spell-binder in front of an enthusiastic and fashionable audience, responding as they might have done to a star of the opera. Fabrizio was speaking, in concealment, of his love for the absent Clélia, and his audience recognised a mysterious yearning of its own in his words. Stendhal's is a world turned upside-down, and become a matter of appearances. The only person on his field of Waterloo with any grasp of the situation is a *vivandière* or *cantinière*, a woman selling refreshments.[11] Knowing how things really are she helps Fabrizio make good his escape. Otherwise he moves in concealment, in a culture of disguises and forms of words which expunge the bitter taste of reality: the Conte, for instance, with whom Stendhal sympathises, knows that he is safe with a new chef who is merry and given to making puns, and 'punning is incompatible with murder.'[12]

Stendhal's personnel have their inauthentic being among the facile language of society: 'People nowadays know how to express everything gracefully, but their hearts have nothing to say.'[13] Real, or compelling, experience comes to Fabrizio in isolation, in confinement in the tower, where he is forced to develop a new and difficult code if he is to communicate at all. The tower, although meant as an exercise in sensory deprivation, appears to bring Fabrizio both to his senses and to a proper consciousness of language. It is a redemptive symbol around which the writer negotiates language and experience, and brings both sharply into focus. The specially-designed room in which he is confined is known as *passive obedience*, but is as much a womb as a prison; constrained, he is paradoxically re-born.

A *Sentimental Education*

Fabrizio's captivity, despite rats and a savage English dog, is enlivened by love and by bird-song. Stendhal, in 1839, was comparatively optimistic. His contemporaries, in painting at least, represented the flesh as irremediably encumbered and trammelled. Delacroix's people of the barricades press on towards a destiny outlined in detail at their feet. They move at the behest of a beautiful idea. Delacroix always admitted to an awkward, distant relationship between humanity as raw material and the culture of words, costume and gesture. His figures can look lost within their garments, as Stendhal's courtiers might be swamped by courtly formulae. He preferred subjects which allowed no reconciliation, which turned out badly, in which the power of words got the better of the flesh. *Marino Faliero*, for instance, may look, in his version, like a celebration of the senses, and it does represent the Doge's farewell speech as imagined by Byron: 'Ye elements!...Ye blue waves!...Ye winds!...Ye stones!...Ye skies!'[14] In the beginning, though, Faliero was unbalanced by a lie against the chastity of his wife, a lie magnified by rumour. *Sardanapalus*, too, another Byron tragedy converted by Delacroix, ends in a giant bonfire of the senses, but it begins with the mob unsettled by the sound of 'Honour' and 'Glory'. The king, though, 'would not give the smile of one fair girl / For all the popular breath that e'er divided / A name from nothing.'[15]

Mere being

Delacroix's humanity, although now reduced, once lived within reach of inspiring ideas. His successors showed such ideas, if not dissipated at least pushed to the margins, as little more than residues. Courbet's theme, for example, was the flesh as an absolute. The *Burial at Ornans*, which he began in 1849, may be as encylopaedic sociologically as an allegory by Balzac, but underlying all else is a hole in the earth, in the soil even, emphatically there at eye-level. A processional crucifix placed against the sky may be a reminder of the Resurrection of the Body, but it stands disregarded by people more interested in each other and in the pit before them. He used similar terms in the *After Dinner at Ornans*, painted just before the *Burial*. In it, music takes the transcendental part, although unheard in the face of all the visual evidence to hand, and an audience of three, plus a sleeping dog, embody the appetites and mere brute being: one lights a pipe, another fingers a glass, and a third watches and listens head on hand. The *After Dinner* established Courbet, and it was admired by Delacroix who

thought that it was without any precedent - apart from his own, he might have added, give or take a change or two: Courbet's fustian and tobacco for his own more *recherché* range of silks and hashish, Ornans in the Jura for a legendary Assyria.[16]

Courbet, Castagnary wrote, 'was afraid of death and never painted it', although he often pictured it as rest and sleep, and in terms of shot and hooked game.[17] The generation of Delacroix, Courbet, Flaubert and Baudelaire was much obsessed, perhaps because of an extravagant love of life, and perhaps too because Death asked awkward questions around the meaning of life. Baudelaire projects lurid, aromatic dreams, more palpable than abstract. Truths and ideals are promised, but against a ground of sensory matter, of amber, musk, benjamin and incense, even in the temple of Nature with its forests of promissory symbols (the site of *Correspondances* in *Les Fleurs du mal*).[18]

Redeemed by women

Lodged in raw material, and victimised by piquant sensory impressions, Baudelaire took some consolation in images of women. His ideals, remembered and remote, are pitiless queens of cruelty, but at least they stand out, help him bring order to his chaos. French culture, deprived of those values which had held it together, looked for a sign sufficiently powerful to maintain itself in a secular and utopian age and found it in the image of a beloved woman, often contrasted to a darker counterpart or *femme fatale*. Baudelaire looked on the shadow side, but such other writers as Flaubert found true love, and it was around true love that the image of France took shape. Love survived the collapse of businesses and of republics. It was undeniable, the only enduring imperative; not agapic love, which involved brotherhood and improvements in the social services, but the other sort which went in awe of an ethereal, ideal woman. It sustains the otherwise shapeless life of Flaubert's Frédéric in *Sentimental Education* where he remembers 'his fits of melancholy at school, and how a woman's face used to shine in his poetic paradise, so that, the first time he had seen her, he had promptly recognised her.'[19] The ideal in question, to whom he is also telling his tale, is Mme Arnoux, faithful wife to the philanderer and variously-failed businessman.

Mme Arnoux was a distinguished one of many. In the *Education* itself there was Louise, who entered in a white skirt spotted with jam stains and with 'something of

the grace of a wild animal'.[20] She married a calculating solicitor friend of Frédéric, before running off with a singer. There was Mlle Vatnaz, who had 'magnificent wild eyes, with specks of gold in the pupils, full of wit, love and sensuality'; she ended as an embittered Socialist propagandist.[21] Frédéric's *femme fatale* was Rosanette: 'there was something insolent, intoxicated, and indefinable about her whole person which exasperated Frédéric, and yet filled his heart with mad desires.'[22] Proust was even more prolific: Albertine, another child of nature, on a bicycle at Balbec; Odette, imagined in Botticellian terms by Swann; 'Rachel when from the Lord', the whore loved by Saint Loup; Mme de Guermantes, in whose name, looks and voice, a place and its culture resonated. Proust wrote exhaustively on love as undergone by Swann, Marcel, Saint Loup, Elstir and the Baron de Charlus. It was never less than complicated. There was the woman herself with her fair hair, piercing blue eyes and large nose (Mme de Guermantes) or her fringe, large eyes and tired cheeks (Odette de Crécy, 'a young woman almost of the demi-monde' beloved by Swann). Sometimes, though, the physical presence of the loved one could hardly be recalled, and scarcely mattered in relation to, say, the idea of Geneviève de Brabant who imbued the identity of Mme de Guermantes. For Swann, Odette was one with Zipporah, the daughter of Jethro as imagined by Michelangelo; at other times she came from Botticelli's *Life of Moses*, or was rumoured as a 'kept woman'; Swann daydreamed of her as 'an iridescent mixture of unknown and demoniacal qualities embroidered, as in some fantasy of Gustave Moreau, with poison-dripping flowers interwoven with precious jewels.'[23] Proust's writer, in his most distanced manner, concluded that loved women are 'a product of our temperament, an image, an inverted projection, a negative of our sensibility'.[24]

Excused by women
Proust implied an ideal which was as transient as it was imperative. It could be learnt, and at one point the writer shows himself seeing with the eyes of the painter Elstir, whose 'beautiful Gabrielle' had at first seemed common, pompous and charmless.[25] If someone like Marcel could be tutored in beauty, and himself and Swann moved by a range of connotations only tangentially related to the loved one, then no certainty remained. It might seem essential, at a certain point, that Gilberte (the Swann

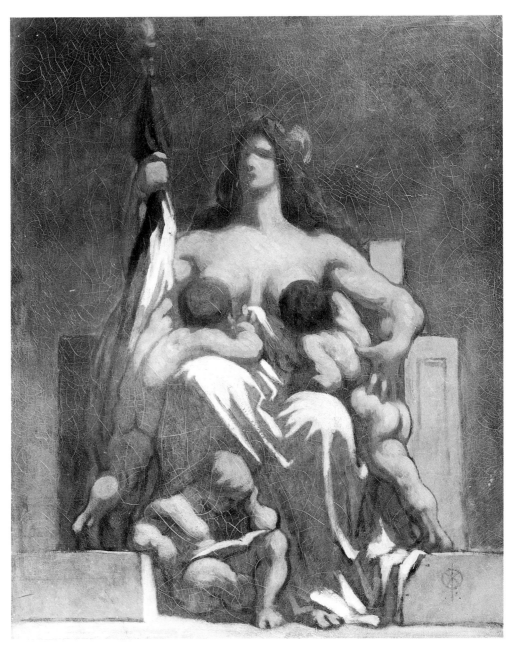

Honoré Daumier
La République, 1848
Musée d'Orsay
Not in exhibition

Immediately after
the Revolution of
24 February, 1848, the
provisional government
announced a
competition on the
theme 'le symbole de la
République'.
450 painters,
31 engravers and
173 sculptors entered work.
Daumier took 11th place
among the painters, and
was asked to complete a
large version for 500
francs. The large picture
was not completed and
Daumier was not paid.

daughter loved by Marcel) or Albertine should be seen, but eventually the impulse fades, in the face of new loves with changed connotations. That is to say, the figure of the idealised woman, loved to distraction, explains or legitimises masculine mutability. Love is real during its duration, even if obscurely founded, and in Proust it could be very obscurely founded: 'Rachel when from the Lord', for example, is given form and outline under the lights on stage, but dissolves on contact into 'a nebula, a milky way of freckles, of tiny spots, nothing more'.[26] Love justified the oddest

behaviour; it was one fact of experience which might be marvelled at, but never argued with, although Marcel was staggered by Saint Loup's lack of judgement à propos Rachel.

If French social and political life was lived in relation to the imposing images of La Liberté, La République, and then Marianne, it may have been in part because they were ideal and exemplary, but at the same time their beauty and their femininity explained, metaphorically at least, the behaviour of their often disreputable menfolk. *Sentimental Education*, for instance, is a love story, and a history and archaeology of France. But who is Mme Arnoux to whom Frédéric is faithful in his heart of hearts, through the long years of poverty, fortune and revolution? Above all, she is an impossible ideal: beautiful, dutifully married and industrious. She is a young mother when first seen by Frédéric, and she has a work-basket by her side. Her predecessor Emma Bovary is also introduced under a sign of industry and asceticism, signalled by the picture of Minerva on the walls of her childhood home. Mme Arnoux is a kind of virgin queen (of France); her husband's eroticism is directed elsewhere, to the slatternly woman from Bordeaux, for example. Frédéric is meant as a man of his time, who moves in society and even hopes to run for office, but, weakness incarnate, he never stands a chance. His failure is explained by his love for this unattainable woman, who at no point seems to have anything to do with the life of her times. Emma Bovary, too, has expectations which none of her inadequates can understand, let alone match up to; and her ideas also come from afar, from Scott's novels and from old pictures. Whatever the ideal woman stood for it was, as registered by Flaubert, beyond the scope of a society of men out for their own limited ends. They were, from the outset, destined to fail, and could almost be excused their failures: Charles Bovary, with a career to make, was tired in the evenings, which left no space for imagination; Frédéric, in his tender years, had dreamed of 'wild orgies with famous courtesans', and that had left its disabling residues.[27] Flaubert remarked on contradictions, or symbolised them, in the shape of that virgin queen who stood for duty in contrast to the libertarian side of post-revolutionary society, evident in the figure of a prostitute posing on a pile of clothes as a statue of Liberty in a ransacked palace during the Revolution of '48.[28]

Either the ideal woman asked too much of her devotees, or she had a sister who,

almost as a matter of course, deranged their judgements. Flaubert described the intoxicating Rosanette, with her bed canopied with ostrich feathers on a dais covered with swan's-skin. Balzac, more programmatic than either Flaubert or Stendhal, told it as an allegory in *The Wild Ass's Skin* in which Raphael is misled by Foedora, a calculating temptress with a heart of bronze. He might have been happy with the beautiful but humble Pauline who tends to him and loves him like a brother, although she too amounts to rather more than the girl next door, as Balzac explains in an epilogue on celestial origins, mirages and hauntings of memory. And failing Foedora there would have been Aquilina, the soul of vice, and Euphrasie, soul-less vice. Balzac's women are society personified: Foedora is heartless High Society; the terrifying Aquilina is the self-destructive revolutionary mob; the restoration monarchy 'was a woman of loose life with whom one could banquet and make merry; and the country itself was 'a virtuous – not to say shrewish – spouse' whose frigid caresses had to be tolerated.[29] Balzac thought readily in terms of ideal and other sorts of representative women in a novel which was also a tract on the times: 'Power, having now lost its unity, is steadily moving towards a social dissolution against which there is no other barrier than self interest.'[30]

Woman as Nature
The domestic, sisterly Pauline, explained in three poetic paragraphs by Balzac, turns out to be an odd figure, transcendental and desirable, and finally a local spirit of place, seen as a figure in white emerging from mist on the Loire near Tours. She reminds the narrator of a ghostly figure from a medieval romance 'seeking to protect her native Touraine from the invasion of modern technology': Balzac's last word to his apparently slow-witted audience. The idealised woman, born of a river and of history in this case, associated France with nature, to form an explanatory figure. France had come into being as a unity and this had been precipitated by the Revolution and the federations of 1790; and that unity was not to be explained in everyday terms. Michelet, especially, was in no doubt as to her femininity; she was loved by the poor who felt themselves obliged to her, and by the rich who felt her obliged to them. The peasant had married her legitimately, and in perpetuity. To the worker she was a lovely mistress, his only possession 'her noble past, her glory'. Free of local ideas, the worker

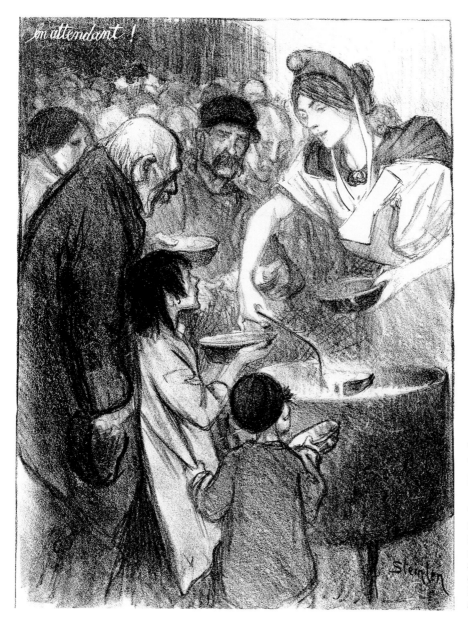

T A Steinlen
While waiting, 1895
Lithograph

The plate, of Marianne
ministering to the
people, appeared in the
programme for a concert
given on 30 March, 1895,
on behalf of the soup
kitchen of the 17th
arrondissement.

adored 'the great unity of France'.[31] In Michelet's syllogism woman was associated with nature through a shared rhythm. She belonged to great sidereal time, whereas man dealt in the quotidian: 'History, which we so stupidly decline in the feminine, is a rude and savage male, a sunburnt, dusty traveller; Nature is a woman.'[32] Stendhal, musing on his redemptive *vivandière* at the incoherent Battle of Waterloo, would have been of that opinion. In Michelet's scheme of things the Revolution had ended historic time, or the practical time managed by men, and installed natural time in its place, the time of women. Flaubert, attentive to the importance of courtesans and their drawing-rooms in the formulation of national policy, might have ackowledged Michelet's vision of the new age.

Michelet's theory, although elaborate and poetic, was endorsed elsewhere. The fundamentals of his vision, written out from the 1830s through to his death in 1874, were recreated in the art of Cézanne whose statuesque female portraits and groups of women bathers might have been programmed by the historian. Man in Michelet's terms was a dry but necessary principle needed to activate the cycle of Nature. Without Nature's order, history amounted to one thing after another in an endless succession. Breaking into the cycle of Nature entailed an act of violence represented in Michelet by Joan of Arc taken by the soldiers, and by female bathers spied on.[33] Michelet also associated his composite of woman and nature with water, a homogeneous, mediating substance. Sterility and disorder were signalled by the presence of gambling and narcotics which meant a collapse into dreams. Distracted by hallucinations and lottery, and by the illusions involved in novel-reading, society forgot to engender. Cézanne's several sets of card-players with their supporting racks of tobacco pipes deserve some explanation, and Michelet on social inertia points in their direction. One of Flaubert's themes, too, represented by dead and threatened children, was sterility induced by the superficial lure of the social. Michelet, like the others, was looking for compelling terms which might express and explain contemporaneity, and in the process he became a myth-maker under the colours of a historian. Nor was Cézanne's painting ever innocent, with its black- and red-haired bathers which imply identity, and those anthropomorphic clouds and inscriptions in the rocks. Michelet's man, too, was born of the earth, more exactly from the flint which nurtured the wheat of France. Cézanne dwelt on the same polarities, water and rock,

the bathers and rocks galore at Bibémus and in the form of La Montagne Sainte-Victoire.

Are those female thighs giving birth in the shape of those white clouds in *The Large Bathers*?[34] Did Cézanne mean to symbolise anything ever? Whatever his declared intentions he was involved in a culture engrossed by the mystery of its own constitution and principles, a culture in which there was no privileged symbolic domain. Meaningful imagery came, as it were, from nowhere, and in spite of such good intentions as made David propose the People as Hercules. The infallible Flaubert prospected in the area and left signs. In *Madame Bovary* he noticed a craze for cacti, stimulated by a fashionable popular novel. In the *Education* he remarked on a richly ornamented dance-hall which had failed because it had been two years in advance of its time.[35] M. Arnoux hoped, with his ceramics business and religious furnishings shop, to predict current drifts, and never did. Pellerin, the painter, always hoped to calculate his way into the *zeitgeist* and became ridiculous in his learned enthusiasms. Had Arnoux taken out a patent on Marianne he might have made the fortune which never came his way. She was a product of the popular imagination, sent out with no very clear reason into the world of the 1850s.

Marianne, or Society as Nature

The heroine of *La Marseillaise* had been a mother to her children, and her successors on the barricades and among the volunteers of '92 are spirited and aggressive. Daumier's *La République*, painted for a competition at the Salon of 1848, is a majestic heroine nurturing two herculean children. But Marianne, a sort of younger sister, lacks definition by comparison. She might be from the same imagination as Fabrizio, the beautiful nullity who features at the centre of the *Charterhouse of Parma*. She might be related to Marcel around whom Proust's three thousand pages centre, or perhaps dreamed up by Michelet. The historian projected an idea of the King of France in the Middle Ages as an empty space, a humble continuation of the culture of the land, and in sharp contrast to the tyrannical kings of England, gross privateers. He also defined France as 'the country of prose', the most transparent and the purest form of writing, 'the least material, the freest, the most common to all men, the most *human*'.[36] Marianne is of that order of (non) existence, a charming creature who might be shaped

or dreamed at will, a gift to painters, sculptors and cartoonists, and a fine companion to the men of the Second Empire, 'light, cynical, sceptical', as Zola described them in his introduction to *La Débâcle*.

A political Marianne appeared first of all in 1637, as a patriotic Jewish princess in revolt against Roman invaders, in a play, *La Mariane*, by Tristan l'Hermite. Another Mariane appears as a heroine in Molière's *L'Avare*: 'La nature . . . n'a rien formé de plus aimable; et je me sentis transporté dès le moment que je la vis. Elle se nomme Mariane.' The name 'Marianno' also came up in the Midi with reference to opposition to the Jacobin Republic of 1792. It was the name given to the Republic of 1848, and after Louis Napoleon's coup it was taken up by a secret society: 'La Marianne'. After 1850 it was a name applied derisively to the Republic. Paul Trouillas, in *Le Complexe de Marianne*, thinks over the name itself with its references to the Virgin Mary, to St. Anne, her mother, and to its familiar use as a diminutive for Mary. It chimes too with the Champ-de-Mars and *La Marseillaise*, with *mariage* and even with the Battle of the Marne. It is at once respectworthy and familiar, warlike and comfortable, virginal and connubial. Trouillas concludes that her name alone answers to a variety of often conflicting desires, from the transcendental to the transgressive. She is, though, consistently young and beautiful, which establishes an idea of the Republic. She confirms, too, the virility of its electorate. Bare-breasted, she is both mother and temptress, and Trouillas concludes that this expresses a French view of politics as transgressive: 'En France, toute politique est vertige et scandale, renversement des tabous usuels.'[37]

Above all, though, – and this is not stressed by Trouillas – she allowed a space in which politics, transgressive or not, might be practised. Rude's proto-Marianne, his spirit of war exhorting the volunteers, made no allowances for the equivocal. The new Marianne, on the other hand, was more chimerical than positive. She was virtually unauthored, without an original, not much more than an echo of names drifting on the edge of consciousness. Where La Liberté and La République had high expectations, Marianne might be imagined as no more than an impressionable, fleeting youngster on her summer holidays at Balbec: Albertine, whose truth Marcel could never quite define, is the type of Marianne. She might promise to be faithful, but could never be relied on. She might respond to the steadying influence of an older or more prudent

J A Roëhn
'J'ai perdu!', 1824,
Engraving

man, but at the same time harboured secrets. Albertine, for instance, had a sapphic past, and present, if only Marcel could get to the truth. And Marianne herself might tire of old men, as she did in 1968.

Women as France

In conclusion, her writers insist that France is a woman. Michelet insisted without discretion, at the end of his account of Joan of Arc:

> The Saviour of France had to be a woman. France was a woman herself. She had a woman's changeableness, but also her attractive sweetness, and a ready and delightful compassion, and her first impulses were good. Even when she took pleasure in vain elegance and outward show, she was at heart still close to nature.

France was a woman, and, conversely and whether willing or not, women were France or of her family, imbued with the grandeur of the idea. The Frenchman, Michelet went on, was of unusually good heart and spirit, even when somewhat lacking ('même vicieux'). Michelet's reservations were excusable in a story disfigured by betrayal and human (male) weakness prompted by 'English gold', Michelet's term for unprincipled forces abroad in the world.[38] Man, as recounted under the new, post-revolutionary terms, was a potentially tragic figure, doing his best in the modern miasma. In the fundamental French fable, recounted again and again, a man is faced with a task, of governing and understanding. He is advised by other men, some wise and others worldly-wise, by atheists and believers in God's grace. He is confronted by local and class interests, by a peasantry born of the place and by the remnants of an aristocracy who also seem to belong. Crises result from the interventions of the dark woman, evil and obstinate, and are mitigated by someone like Joan, a girl with a lantern who happens to be there. In the end he goes under, but in the meantime there were those visionary instants when France herself intervened. In essence it is a story made up around male tribulations and the problem of government.[39]

1 Jules Michelet, *Le peuple*, Preface, 1846. Quoted in Roland Barthes, *Michelet*, Basil Blackwell, Oxford,1987, translated by Richard Howard, p. 77. Between 1833 and 1867 Michelet published a history of France in seventeen volumes. His *La Sorcière* of 1861 is recommended by Georges Bataille in *Literature and Evil*, Calder & Boyars Ltd., London, 1973, translated by Alastair Hamilton, after the Gallimard edition of 1957.

Jules Michelet, *Jeanne d'Arc* (extracted from the fifth volume of the *History of France*), Gallimard, 1974: 'Le Sauveur de la France devait être une femme. La France était femme elle-même,' p. 151.

A Sentimental Education

2 From *Le Chant du départ*, by M J Chénier, quoted in the context of a long analysis of *La Marseillaise* by Paul Trouillas in *Le Complexe de Marianne*, Éditions du Seuil, Paris,1988 (in the series *L'Histoire immédiate*), p. 131.

3 Paul Trouillas, op. cit., p. 78.

4 Paul Trouillas discusses the giants at length, op. cit., pp. 226-32. 'Liberté chérie', who fights alongside defenders of 'la Patrie', is from the sixth stanza of *La Marseillaise*.

5 David's *Death of Bara* (Musée Calvet, Avignon) is discussed by Robert Rosenblum in *Transformations in Late Eighteenth-century Art*, Princeton, 1967, pp. 84-5.

6 *Rameau's Nephew* was translated by L W Tancock for Penguin Books, Harmondsworth, 1966.

7 Gustave Flaubert, *Sentimental Education*, translated by Robert Baldick for Penguin Books, Harmondsworth, 1987 edition, p. 373.

8 Ibid., p. 240.

9 Ibid., p. 305.

10 Ibid., p. 411.

11 For a *vivandière* in detail see Roger Fenton's photograph in *Roger Fenton, Photographer of the 1850s*, South Bank Board, London, 1988.

12 Stendhal, *The Charterhouse of Parma*, translated by Margaret R B Shaw for Penguin Books, Harmondsworth, 1986, p. 426.

13 Ibid., p. 205.

14 Lord Byron, *Marino Faliero, Doge of Venice*, act V, scene III. He appears also in Flaubert's *Dictionnaire des idées reçues*: 'DOGE – on n'en connait qu' un: Marino Faliero.' The dictionary was compiled in the 1860s and meant to form part of *Bouvard et Pécuchet*.

15 Lord Byron, *Sardanapalus, a Tragedy*, act I, scene II.

16 See the catalogue entry to *Gustave Courbet, 1819-1877*, Arts Council of Great Britain, London, 1978, p. 207.

17 Ibid., p. 97.

18 No. IV in *Les Fleurs du mal*, in *Baudelaire: the Complete Verse*, edited, introduced and translated by Francis Scarfe, Anvil Press Poetry, London, 1986.

19 Gustave Flaubert, op. cit., p. 270.

20 Ibid., p. 99.

21 Ibid., p. 82.

22 Ibid., p. 214.

23 Swann's versions of Odette appear in Marcel Proust, *Remembrance of Things Past*, vol I, *Swann's Way*, translated for Penguin Books by C K Scott Moncrieff and Terence Kilmartin, London, 1983: Odette after Michelangelo, pp. 242-6; in Botticelli's *Life of Moses*, p. 260; after Moreau, p. 292.

 Proust's lifework *Remembrance of Things Past* is divided into seven parts: *Swann's Way* (1913), *Within a Budding Grove* (1919), *The Guermantes Way* (1920-1, 2 vols.), *Cities of the Plain* (1922, 3 vols.), *The Captive* (2 vols.), *The Sweet Cheat Gone* (2 vols.), *Time Regained* (2 vols.), the last three titles published posthumously.

24 Marcel Proust, op. cit., *Within a Budding Grove*, p. 955.

25 Ibid., p. 909.

26 Proust writes of Saint Loup's Rachel in *The Guermantes Way*, vol. II, p. 177.

27 Gustave Flaubert, op. cit., p. 26.

28 Ibid., p. 290.

29 Honoré de Balzac, *The Wild Ass's Skin*, translated by Herbert J Hunt, Penguin Books, Harmondsworth, 1986, p. 57.

30 Ibid., p. 72.

31 Roland Barthes, op. cit., p. 198, from *Le peuple*, vol. 1, p. 8.

32 Ibid., p. 148, quoted without details.

33 Jules Michelet, *La Mer*, Paris, 1861, republished by Gallimard, 1983, pp. 309-14, as *Bains – Renaissance de la beauté*, reprinted in Roland Barthes, op. cit., pp. 168-70.

34 In the National Gallery, London.

35 Gustave Flaubert, op. cit., p. 80.

36 Roland Barthes, op. cit., p. 39, from Michelet's *Introduction à l'histoire universelle*, 1831.

37 Paul Trouillas, op. cit., ch. V, 'Marianne, mère et maîtresse', pp. 201-75. Trouillas's vivacious account of Marianne ranges from pre-history to the present via museum collections, comic strips and TV advertisements.
 In the same book he looks in detail at celebrations on the 14th July, and at the Eiffel Tower (designed to celebrate the centenary of the Revolution) and *La Marseillaise*.

38 See note 1, *Jeanne d'Arc*, p. 151.

39 For a thoroughly French fable: Georges Bernanos, *Journal d'un curé de campagne*, Librairie Plon, Paris, 1936, in which the *curé* dies protractedly, as a result of a diet of old bread soaked in poor wine, which might represent the hardships of life on that particular earth.

Household deities

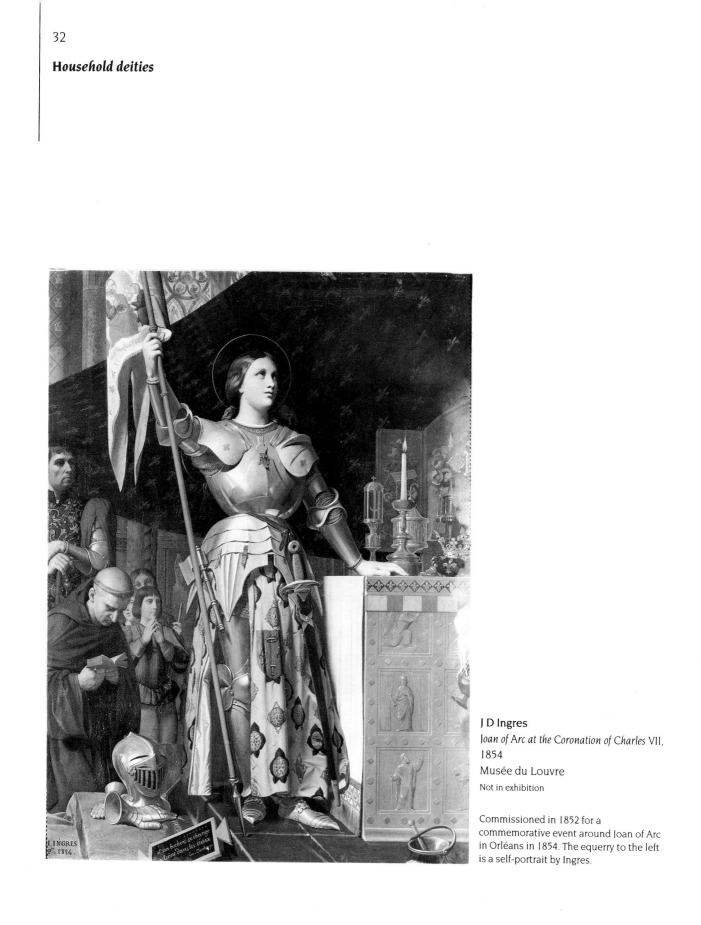

J D Ingres
Joan of Arc at the Coronation of Charles VII,
1854
Musée du Louvre
Not in exhibition

Commissioned in 1852 for a
commemorative event around Joan of Arc
in Orléans in 1854. The equerry to the left
is a self-portrait by Ingres.

France had been singled out, by God and against the better judgement of Frenchmen. God's sign was a woman, Jeanne d'Arc, a country girl from Lorraine. She heard voices which instructed her to be a good child, to go often to church, to go to the rescue of the king of France and to restore his kingdom to him. In 1429, aged eighteen, she undertook her mission, raised the siege of Orléans, routed the English, and brought about the coronation of Charles VII in the cathedral at Reims. Her campaign to free her country from the English foundered in front of Paris. Betrayed, or sold, to the English she was, after long and thoroughly recorded trials, found against and burned at the stake in Rouen in 1431.

Jules Michelet gave a most moving account of Joan in the fifth volume of his history of France (1841). An irresistible story, he admitted, which acted directly on the heart. Michelet's Joan is not just a regional heroine, but the Virgin Mary come down to earth, 'une vierge populaire, jeune, belle, douce, hardie'.[1] No young English or German woman, Michelet began, would have braved such a man's world, whose horrors he emphasised.[2] Michelet's *tour de force* was the trial in which he described a world of *realpolitik*, presided over by pharisees and doctors in thrall to politicians: a story of and for his own times. Michelet outlined a society marred by prudence and by self-interest – to a point of anarchy. Joan, bearer of the word of God, was alone capable of redeeming this fallen and shattered world, and at one point Michelet wrote of the brigands who constituted the French army entering, under Joan's inspiration, into a new life. She was the Virgin Mary, and at the same time a harbinger of the Revolution in which all would be remade.

She was a patriotic and valiant woman; and so were many others at that time, Michelet admitted. What distinguished her was a story whose elements retold the life of Christ in contemporary terms. Both were betrayed for cash, both judged by accredited state specialists, and both executed for reasons of state. France, for good or ill, was settled with a profoundly moving story of national liberation, which associated government with hypocrisy, weakness and barbarism (Gilles de Retz, for instance, one of the captains of the time, was the original of Bluebeard). It established too in Joan an impeccable ideal of nation. There could be a new start, marked by hope and goodwill to all men. Michelet described the moment, out of doors with an altar raised in the valley of the Loire; a change of heart and then on to Orléans, and after that Jerusalem: a premonition of the world mission which became part of the Revolution.[3] She endured in these terms: in George Bernanos's *Journal d'un curé de campagne* (1936) Christ's entry into Jerusalem leads into her entry in triumph into Orléans; and the foreign legionnaire telling the story then, a contemporary man on a motorcycle, cites her as the last true soldier in France, dead

on May 30th, 1431. Bernanos's legionnaire was speaking on behalf of a spirit gone from France, a spirit which was at once pious and martial, which recognised no distinctions between the sacred and the profane.[4]

Michelet's Joan is an intriguing figure, not because of any psychological complexity, but because of suspicions aroused at every point in her career. He shows her questioned by friend and foe alike, and from the outset. It is as though the authorities were driven to distraction by her innocence, by a very absence of character. Bernanos's voice of experience, the *curé de Torcy*, has a lot to say about her with respect to the Virgin Mary, her precursor. He pictures Her as a figure of absolute innocence, unacquainted with sin or with any facts of life at all, and goes on to imagine a tableau in which She stands defenceless but invulnerable in front of 'la Ruse et l'Orgeuil', cunning and pride, characterised as two terrible patriarchs or age-old demons who had been with man (Adam) from the beginning.[5] Michelet's Joan, too, falls foul of the same demons: 'Ce vice immense, profond, c'est l'orgeuil.'[6] Michelet mitigated the horror by rooting it in the England of Winchester and Warwick, but the wiser *curé* knew that it was indigenous. Bernanos concluded that this image of purity and innocence was too much to be borne, too distant, too perfect. In a harrowing scene in the *Journal d'un curé* the young priest, vomiting blood in a ditch, is rescued by Séraphita, a Virgin-Child bearing a lantern. The priest understands, facing this vision, that it represents a perfection to which men have necessarily been blinded: a vision, that is, both given and withheld.[7]

Joan and the Virgin Mary were invoked by Michelet and Bernanos in texts meant to condemn and to redeem France. Both, fundamentally the same figure, were absolutes who made no allowances for the pride and cunning necessary in government, and for survival. Flaubert, interested in life as practised by the imperfect, disposed of the Virgin as a vulgar arrangement in a satin robe and tulle veil with silver stars, looking, in the church at Yonville-l'Abbaye, like an idol from the Sandwich Islands. And the Holy Family nearby had been 'presented by the Minister of the Interior'.[8] In *Sentimental Education* he was almost wistful in front of the decorations at Fontainebleau where the old world had tried to convert itself into a dream of the Hesperides. Diana the Huntress was there, in honour of Diane de Poitiers, mistress of Henri II, but Rosanette, the courtesan with the swan's-skin bed, knew nothing of her, and scarcely cared.[9] Other great women pass by in Flaubert's parodies: Athalie, for example, become a name for a daughter of the disgraceful Homais – Athalie, who went against God in Racine's last tragedy. It is, Flaubert implies, almost too difficult to entertain any image of the ideal. Its meaning has either been forgotten, or what is about to be disclosed makes it intolerable: that

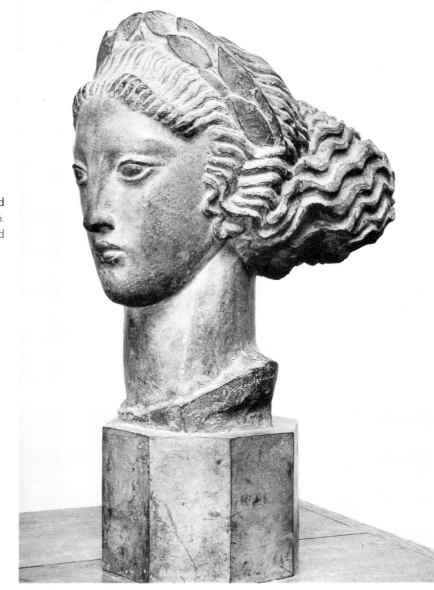

Henri Bouchard
Tête de Victoire, 1926.
Musée Henri Bouchard

head of Minerva in black pencil in Emma's childhood home, over the letters 'To dear Papa', in a room which might be meant to stand for Old France. It is Minerva, the goddess of handicrafts, who with Venus and a ubiquitous maternal goddess peoples the gallo-roman displays of French museums: household deities in miniature, which insist on that formative France as an industrious and fecund world of beautiful women.

Although Proust was less dismissive of the great inheritance he admitted it as a private and anachronistic matter. The Duchesse de Guermantes personified France, time and again. She was in fact plain Mme de Guermantes, for duchies and principalities were of the old order, but in the writer's eyes the old names became

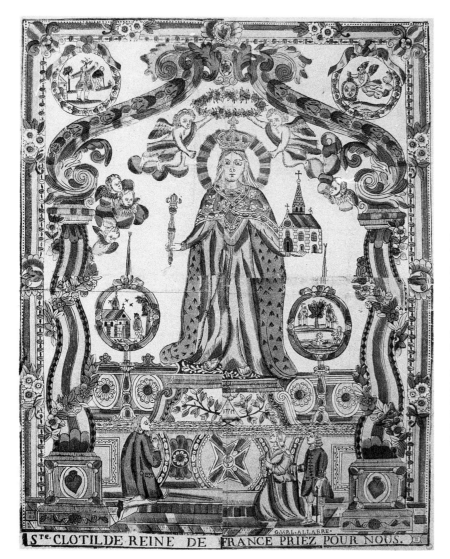

St^{te}·CLOTILDE·REINE DE FRANCE PRIEZ POUR NOUS.

L Allabré and T Blin
St. Clotilde Queen of France, pray for us.
Wood engraving with stencilled
colouring
Musée National des Arts et
Traditions Populaires, Paris

Undated, although Allabré was active from
the 1760s.

St. Clotilde was widow of the
Frankish king Clovis, whom she
had helped to convert to
Christianity. Clovis united the land,
which was then divided amongst
his four sons, who feuded.

current in her stature, tone of voice and in the very sound of her name. She was variously a figure in a stained glass window, a saint from the early days of Christianity and a landscape incarnate. She spoke an ancient, pure French, akin to that of Françoise, the countrywoman who cares for Marcel throughout.[10] Neither of these representatives of France seems to age. The Duchesse de Guermantes is Proust's most spectacular figure, and ought to be for she is, indeed, France. At one point he refers to her as an aggregate of all the women who had ever borne her name. On the other hand, speaking the French of Henri IV meant that she had inherited the *mentalité* of that age, which in turn meant that she could scarcely intervene in the France of her own time.

Marcel's imagination was governed by traditional iconography which had kept its authority. Mme de Guermantes was, at one point, an ancient figure in stone holding in her hand a miniature of a city or church which she had either built or defended.[11] Albertine, the girl on a bicycle with whom he fell into perplexing love, was Eve born

in romanesque stonework and then remembered as a French peasant woman carved in a tympanum.[12] Such associations were at the root of Marcel's desire. If not with Adam at the Creation of Eve he was, in imagination, with Racine, and especially with Phaedra, whose declaration of love for Hippolytus helped him explain his own obsession with Albertine. Racine recurs in Proust's text, as he does in Stendhal and Flaubert. Stendhal's *Charterhouse of Parma* is a retelling, with such enfeebled compromised ingredients as fit the new age, of *Phaedra*, with Fabrizio, the handsome juvenile lead, as Hippolytus and the Sanseverina as Phaedra herself. Proust registers a further deterioration, for although he is able to reflect on his own predicament in Racinian terms, he has the public at large attending to Racine less for the play's sake than to witness Berma,a proto-Piaf whose performances were a manifestation of life itself. Proust's world is marked by traces of an inheritance become anachronistic and inefficacious. Under the new dispensation which applies in his own age, authority is intuited and transient: towards the end Berma reappears in her last 'scene', looking like a marble figure in the Erechtheum, almost petrified. Deserted by public and admirers, she constitutes a Proustian fable on the rejection of fixity, on the past and its motifs as inertia.

1 Jules Michelet, *Jeanne d'Arc*, op. cit., p. 64.
2 Ibid., p. 56.
3 Ibid., p. 65.
4 Georges Bernanos, op. cit., p. 266.
5 Ibid., pp. 229-31.
6 Jules Michelet, *Jeanne d'Arc*, op. cit., p. 132.
7 Georges Bernanos, op. cit., p. 237.
8 Gustave Flaubert, *Madame Bovary*, 1857, Flammarion edition, 1987, p. 135.
9 Gustave Flaubert, op. cit., pp. 319-20.
10 Marcel Proust, *Remembrance of Things Past*, op. cit., vol. III, p. 27 (towards the opening of *The Captive*, 1923).
11 Ibid., p. 23.
12 Marcel Proust, op. cit., vol II, p. 381.

Françoise

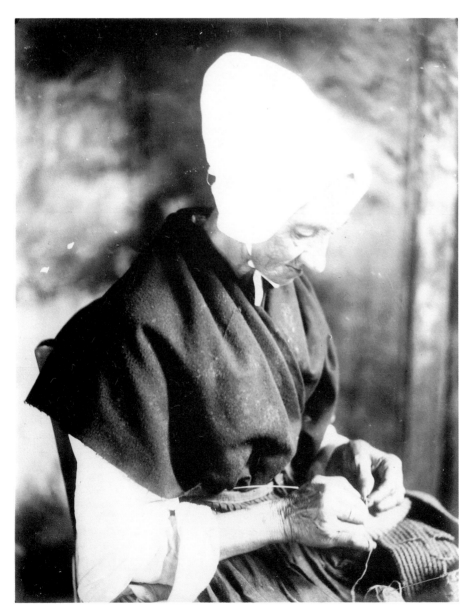

E Fréchon
Needlework, c.1900
Royal Photographic Society

Fréchon won a gold medal at
the Paris Exposition in 1900,
and spent his summers at
Étaples, near Calais

Françoise

Flaubert remarked on her at the Yonville Agricultural Show, where she won a silver medal to the value of twenty-five francs for fifty-four years service on the same farm. Catherine Nicaise Elisabeth Leroux of Sassetot la Guerrière wore clogs and a blue apron, and her face was as wrinkled as an old apple under a cap without a border. Her hands, stained and etched by soda, dust and grease, would never look clean again. Used to tending animals, she had almost become one herself. Flaubert introduced her in the course of Emma's last and fatal courtship. She stood, in his eyes, for reality, though she promised her medal to the *curé*, to say mass for her.[1]

Proust gave more thorough details in his analysis of Françoise, the cook who was put in charge of the young Marcel at Combray. Françoise and the Duchesse de Guermantes between them represented France. The Duchesse de Guermantes spoke not just for but as the old aristocracy. Françoise had access to a code which seemed to have come to her from ancient history. Just as the Duchesse lived always in an ideal maturity so Françoise was for ever elderly, and often likened to ancient motifs: a saint in a niche, a miniature of Anne of Brittany painted in a Book of Hours. Françoise, who supervised Marcel throughout, was there as a gauge. Not only did she have an intuitive sense of a national code, inaccessible to Marcel, a tentative man-in-the-making, but she had good taste, which distinguished her from many of the households on which Marcel reported. He was interested to see how she responded to such confused modern hybrids as Bloch and Saint Loup. Proust's men struggled with their own erring impulses and uncertain roles, and Françoise passed judgement.

Françoise was defined in turn against an even more primitive version of an original France incarnate in Mlle Marie Gineste and Mme Céleste Albaret, *courrières* met in the Grand Hotel at Balbec. They are from a region of torrents among high mountains in the centre of France, and the spirit of those waters moves in them. They look down on all foreign 'vermin', and allow Marcel to air the view that human blood 'is only an internal survival of the primitive marine element'. Céleste is a literally true creature of nature, who not only preserves the rhythm of her native streams but shines with the light of the sun, 'truly celestial'. They are alone in giving a report on the writer, whom they describe as a perfect miniature who might be found in a glass case, and an enchanter at the same time who could be listened to for ever. They constitute Proust's (Marcel's) most condescending and appreciative audience. In the face of such absolute, autochthonous standards the writer was defined as inconsequential, no better than an entertainer, or silver-tongued *jongleur* in the court of *La France*.[2]

1 Gustave Flaubert, *Madame Bovary*, op. cit., part 2, section 8, p. 217.
2 Marcel Proust, op. cit., vol. II, pp. 875-7.

Tragedy and beauty

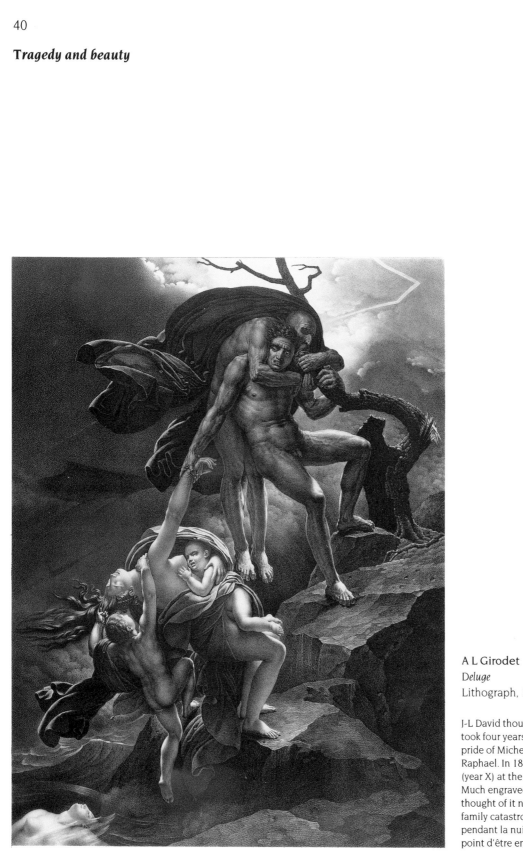

A L Girodet
Deluge
Lithograph, 1825, after painting, 1806

J-L David thought that this painting, which
took four years to complete, combined the
pride of Michelangelo and the grace of
Raphael. In 1809 it won the Prix Décennal
(year X) at the expense of David's *Sabines*.
Much engraved and lithographed. Girodet
thought of it not as The Flood but as a
family catastrophe: '... une famille surprise
pendant la nuit par l'inondation est sur le
point d'être engloutie par les eaux.'

Tragedy and beauty

Parapine, a sordid but vivacious Pole who kept Ferdinand company in Céline's *Journey to the End of the Night* (1932), explained French history as a combination of restlessness and lack of capacity. Robespierre had been guillotined because he kept repeating the same thing over and over again and it was Napoleon's tragedy that he was obliged to furnish a sedentary Europe with a longing for adventure: 'An impossible task. It killed him.'[1] Louis-Ferdinand Céline wrote a modern parable which, although set in the trenches, in hospitals, asylums, in tramp steamers and on the streets, might have been meant to take account of the story from the beginning. His title, for a novel which established him as the modern Rabelais, came from the 'Song of the Swiss Guards' (1793): 'Notre vie est un voyage / Dans l'Hiver et dans la Nuit, / Nous cherchons notre passage / Dans le Ciel où rien ne luit.' A dark night, and nothing to steer a course by: 'Hero and Leander' was a Restoration subject, painted by Chassériau, for example, and in that story the lights go out fatally for Leander crossing the water to his lover Hero, the priestess of Aphrodite.

France was embarked on a dangerous journey, and the stars were unreliable. Géricault's survivors on *The Raft of the Medusa*, deserted by their leaders and reduced to cannibalism, stood as spectacular evidence of these hardships, in the Salon of 1819. And Delacroix too was fond of the metaphor of the boat adrift. There is his version of the shipwreck of *Don Juan* (1840), based on the horrors of Byron's second canto, where on the fifth day they eat Juan's spaniel and on the sixth its hide, before passing on to Pedrillo and others. In the 1850s he turned, thrice, to Christ and the disciples on Lake Geneserath (St. Mark, IV, 37-41) in a boat in a great storm of wind. He looked into the moment in which the disciples doubt: 'Master, carest thou not that we perish?' For all they knew this was the moment when things were finally to fall apart.

Théodore Chassériau, a pupil of Ingres, and Delacroix's contemporary, was as preoccupied by the image of humanity adrift. When he was seventeen he showed *The Return of the Prodigal Son* in the Salon of 1836. The son returns to his father against the background of a large sky and a trackless void. *Cain Cursed* was his other entry in 1836, and Cain was another Byronic hero who asked questions and ended up in wilderness: 'Eastward from Eden will we take our way.' Byron's *Cain* was written in the summer of 1821, and *Don Juan* begun in July 1818. Michelet's John Bull, busy with gold, bribery and *realpolitik*, was an already well-informed guide to the new secular uncertainty, as the painters admitted.

Amongst the blasphemy, cannibalism and despair on Don Juan's longboat there were tender moments, one in particular which involved a father's love for a sickly child a long time in the dying. Humanity, deserted, was vulnerable and touching in its vulnerability. Antoine Watteau had remarked on human mortality and

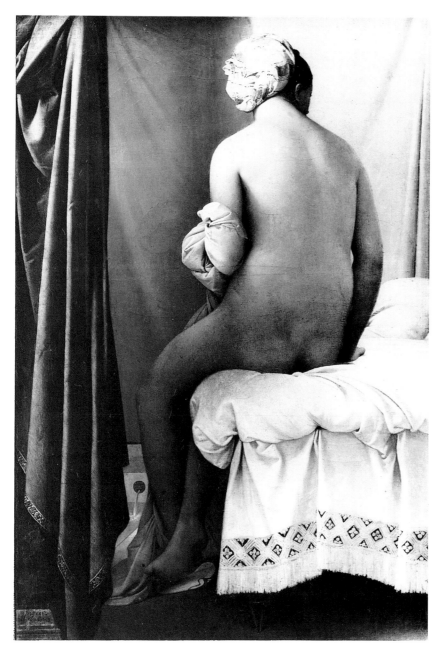

J D Ingres
The Valpinçon Bather, 1808
Musée du Louvre
Not in exhibition

Painted when Ingres was at the Académie de France in Rome, and virtually disregarded until the *Exposition universelle* of 1855.

unpreparedness in the form of those poorly-shaven harlequins in silk in pastel landscapes. Post-revolutionary humanity, though, was far more poignant: presented by David it was liquid-eyed and tender-skinned, thoroughly mortal. Courbet and a later generation worked through signs: an apple and a tobacco pipe to invoke taste. David, by contrast, was more intent on the fragility of skin and brimming eyes. They (David, Ingres, and Hippolyte and Auguste Flandrin) were engrossed by the body intact, enhanced and displayed by necklaces, bracelets and lacework collars. Ingres's

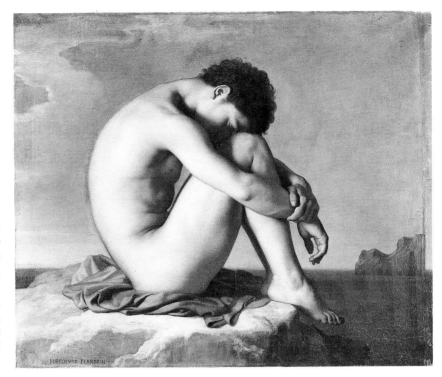

Hippolyte Flandrin
Nude Youth seated on a Rock, 1835-6
Musée du Louvre
Not in exhibition

One of the envious, blind and hopeless, in the Second Circle of Dante's Purgatory, 13th canto. At this time Flandrin was completing a picture of Dante and Virgil in Hell.

Valpinçon Bather of 1806 is just such an intact container, full and complete, though open to damage as he suggests in such supporting details as the foot of a bed, sharp as a lance head, and a spout, the only moving part in a very still picture, pouring its contents into a bath. Throughout, Ingres's tender organisms are jeopardised by sword points and spears, as if they might be easily slit and drained; as vulnerable, that is, as David's Hector mourned by Andromache or his Marat assassinated (in a tub with both the wound and the knife on show). In portraiture pure and simple, such as that of the Flandrins, costume, skin and ground make up an exquisite ensemble, an envisaging of scent, touch and taste, a synaesthetic harmony refined enough to take the breath away. Hippolyte Flandrin found a complete figure for human isolation in 1835 in the shape of a nude youth crouched on rocks on an empty shore, but where beauty and fragility were at issue, women featured.[2]

1 Louis-Ferdinand Céline, *Journey to the End of the Night*, translated by John Marks for Chatto & Windus, 1934, p. 374.
2 See the catalogue *Hippolyte, Auguste et Paul Flandrin*, Musée du Luxembourg, Paris, 1984-5.

Moments

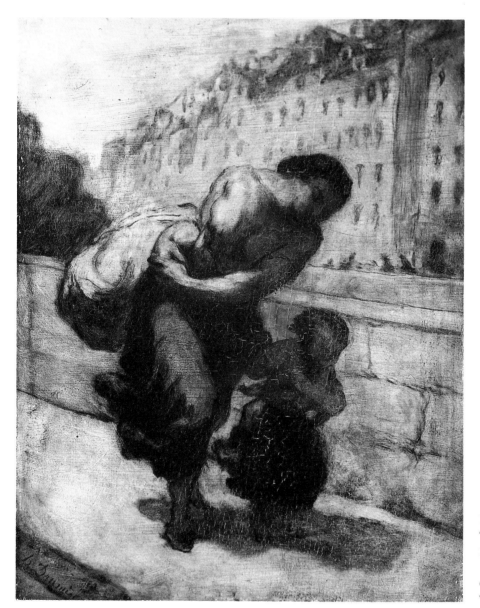

Honoré Daumier
The Burden, c.1860
Burrell Collection

One of six paintings of burdened
washerwomen by Daumier.

Realism took time, and had to if it was to do justice to the complexity and weight of human being in the world. When Courbet painted *The Corn Sifters* in 1855 he told the whole story: one girl, in a dream, works with her finger tips; her companion in red uses the whole of her body; and a youth, with a man's responsibilities, inspects the innards of a machine. Tall, cylindrical grain sacks express bulk, and nine trays, funnels and containers demonstrate variously enclosed space. The floor is screened by a sheet, a foot separates from its clog, and a door is signalled by its latch. Elsewhere the air is scented by flowers or torn by the sound of hunting horns. Trees stand in rocky surrounds, and cattle, always a sign of absolute being, rest in the shadows of the trees. There can be no mistaking Courbet's intentions. His pictures entail a deliberate inspection of memory, with respect to, for instance, the barking of dogs, the taste of tobacco or the feeling of snow underfoot.

Realism was literally, and necessarily, pedestrian, and especially so in Courbet's art where things were represented distinctly and separately, as if to assist recall. It was never an art of the moment, for not only did it take time to construe but it also came enriched, heavy with history. J-F Millet, especially active in the 1850s and '60s, looked back, or gave his commentators the chance to look back, to Michelangelo, Mantegna and Dürer, and to think of the lives of the Virgin and of Christ. If Millet opened his figures it was to atmosphere and earth. They mediate between the air and the soil they till. Both Courbet and Millet (usually termed a naturalist) worked in the public domain, within the limits of a collective memory which had known hunger, evening light and fatigue; but both set terms to experience, and above all to experience of time, which they show as the heroic culmination of a collective history.

Proust, in his *vade-mecum*, identified the flaw in realism: it undervalued the moment, and lacked intensity. Those who live most fully in the sweetness of the moment make of it 'a compelling masterpiece of grace and kindness', but then have nothing left to give. Love expressed in that moment is intense, yet scarcely survives. Proust was more exhilarated than depressed by that capacity, which he associated with Mme de Guermantes; it meant forgetting, a force which was a powerful instrument of adaptation to reality, in that it destroyed the surviving past which was in contradiction with that reality.[1]

There was more involved than a taste for liberty on Proust's part. He reflected further on time in relation to art when he wrote of the painter Elstir, and had Elstir speak on behalf of the beauty of the world seen in passing, all cherished by the same light. Elstir's mature mode projects the luminous instant 'when the lady had felt hot and had stopped dancing', and the writer recognises in it the poignancy of time which had passed and could not be recaptured. Nevertheless, what interests Marcel,

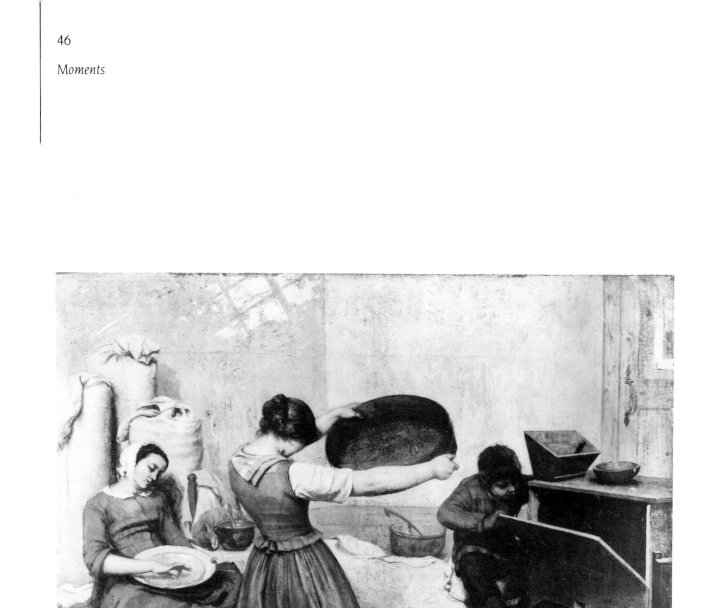

Gustave Courbet
The Corn Sifters, 1855
Musée des Beaux Arts, Nantes
Not in exhibition

despite himself, is an earlier manner which sounds close to that of Puvis de Chavannes or even Moreau. In one of these early Elstirs the Muses are represented 'as though they were creatures belonging to a species now fossilized.' In another a Centaur carries an exhausted poet on its back up a hill, and further along a Muse walks with a poet who, 'characterized by a certain sexlessness', would have interested a zoologist. That is: Proust connected the synthesising manner with fossilization, impotence and inertia. Time, on the other hand, the ecstatic time of the Guermantes moments, he associated with women and with love. Calculated, clock time was inimical to humanity: the last of Elstir's paintings described is a vast landscape so precisely lit that the very minute can be told – and in it the fabulous heroes are almost lost from sight.[2]

1 Marcel Proust, op. cit., vol.II, p. 567.
2 Ibid., p. 437.

Paul Gavarni

'La Fée: (Tout haut) Allez jeunes amants ne cessez pas d'être vertueux et la fée brillante veillera sur vous. (Tout bas) Hue!'
Coloured lithograph from the series 'Les Coulisses' published in *Le Charivari*, 1837-43

The good fairy exhorts young lovers to virtue, in which case she will look over them. The scene-shifter has doubts. Both Gavarni and Daumier favoured behind-the-scenes imagery.

Modernism

The Revolution ushered in the modern age, although modernism took time to clarify itself. Flaubert's Homais in *Madame Bovary* knew all about it. There was to be no more mumbo-jumbo . . . under the aegis of the Supreme Being, an ineffable Creator who imposed duties on citizens and on parents, yet who was at the same time to be compatible with physical laws. Thus Flaubert disposed of the Supreme Being: Homais, cliché-hungry, was entirely a product of culture as acceptable chatter. What, then, remained? Nothing reliable. Flaubert filled the gap with observation, as most of his successors were to do. Flaubert's human being is a superior animal, capable of miracles of imitation, and fathomable under examination. Those purely determined by imitation were nullities, and those who let passion play its part became victims. The modern condition, as identified by its laureates Flaubert and Proust, lacked any impartial, external authority. There were imperatives, but they were mysterious and arbitrary, like that deafening cartload of iron rods which awakens Emma one morning when the fates are about to close in.[1] Lacking reliable premises, chaos could ensue: the culminating social event in Proust's *Time Regained* (1927) is an ill-ordered party, attended for all the wrong reasons.

Absent authority is a pre-condition in modernism. but it had been there from the beginning. It was masked initially by the spectacle of human suffering as phrased by Géricault and Delacroix. Realism, at least as practised by Courbet, announced absolute desertion, though all in the shadow of the cross. If Courbet was consoled by rocks and stones and trees, his successors, following Flaubert's example, began to remark on how society organised itself in the face of the void, or thrown back largely on its own resources. There grew up an interest in mere appearance, show, spectacle and fraud. Flaubert's personnel, especially in *Sentimental Education*, are contrived, made-up, culminating in old Georgine Aubert, dubbed the Louis XI of prostitution, and seen horribly painted at the races. Flaubert was attentive to artifice and to costume, and to the kind of studied behaviour which would be reported on by Degas, which would be his only subject. Degas's people are a function of society; they wear costumes which identify them as gentlemen, jockeys or dancers. They learn how to go about their business, and it becomes quite a matter of routine; his dancers train by numbers, and in surroundings which dictate strictly practical behaviour. Degas's is a world of raw material or human resources gradually shaped by society. That, of course, was also Flaubert's perception, but despite his cynicism he allowed society a hand containing dangerously wild cards, inscribed by Sir Walter Scott and Lord Byron. Things could turn out scandalously badly, and in the process an idea of human worth might be sustained. Degas's view, put forward in an art which declared itself artfully (in colour, line and tone, all distinct), was far more dispassionate, even

ruthlessly so. Denise Rouart stands, in 1884, behind her father's empty chair, among his possessions, among the books, the Millet and the Corot, all assembled round an absence. She exists, Degas emphasises, as her father's daughter, on an equal footing with his things, no more and no less. He insisted that there was no more to life than met the eye – so consistently that he must have surmised otherwise. For him, and for such successors as J-L Forain, the rules of the game had it that the emperor was indeed unclothed, mere flesh in a top hat sustained by the kind of received ideas which would have excited the collecting instinct in Flaubert: 'Voltaire said: the first one to compare a woman to a flower was a lover, the second was an imbecile . . .'[2]

Degas announced modernism as a deconstructive, analytical mode which put process on show within a culture which was itself an artifice. Delacroix might have allowed as much, but his protagonists chose to go out with a flourish, defiant at the last. Courbet insisted on the horror of life wrapped up in mere flesh and earth. Degas, Manet and the generation which followed denied themselves such consolations, limiting their project to what might reasonably be coped with. Modernism, as practised by that generation, relished self-denial. Proust, a studious guide to almost every aspect of French life before and after, found an extravagant figure for modernism towards the end of his great enterprise, in *Time Regained*. Bloch had been known to Marcel for volumes past, as an awkward Jewish friend, but at last he found a means of organising his appearance and identity. Bloch affected a monocle, 'an element of machinery' which absolved his face 'of all those difficult duties which a human face is normally called upon to discharge, such as being beautiful or expressing intelligence or kindliness or effort.' Bloch was the New Objectivity incarnate.[3]

Modernism was impersonal, and radically so in the 1920s when Bloch hit upon his final form. The problem was inwardness, which was fundamentally incompatible with the new mode. Flaubert had admitted personality as a terrible mystery. It was as though the next generation wanted to repeat *Madame Bovary* without the heroine, or there as little more than a report in a local newspaper after international news of executions in Mexico. But the new dispassionate ideal or affectation brought new difficulties, both political and pictorial. What survived? In Degas's art it was a combination of flesh, learnt gesture, costume and cosmetics. Manet's was the same world minus flesh and blood. Both, despite their studied disenchantment, continued to represent a shared social world. Manet, in particular, suggested that the job could not be reliably done, that it might come out looking like a poor wire-photo. What, then, could be relied on? Taste. If the wide, social world was infinitely complex and unfathomable all that could be reasonably reported on was evidence of the senses.

Edgar Degas
Hélène Rouart in her Father's Study, 1886
National Gallery, London
Not in exhibition

Hélène among the possessions of Henri Rouart, an industrialist, collector and painter, and long-time friend of Degas: 'Every Friday the faithful Degas, sparkling and unbearable, enlivens the dinner table at M. Rouart's. He spreads wit, terror, gaiety. He mimics piercingly and overflows with caprices, fables, maxims, banter'. (Paul Valéry)

Desire was an abyss with monsters which had claimed Emma and around which Marcel had skirted for so long with the aid of Racine and romanesque sculpture. The taste of coffee and cake, on the other hand, and the feel of bathwater or the light under those trees, these might be known and registered with some confidence. Bonnard's art, for instance, is rich in that sort of (apparently) immediate experience of pleasurable consumption in the lamplight: a bottle of wine, a gingham tablecloth, a cake, and a dog's muzzle to signal the senses. The paradox of that seemingly immediate, *intimiste* modernism is its deliberated, investigative nature. A Bonnard painting around the pleasures of a drink on the terrace is there to be investigated, read through for indications of sentience. The further modernism retreated into purely personal experience, matters of the senses, the more it became involved in

Rue des Nations, les visiteurs du dimanche.

C Huard
Rue des Nations, les visiteurs du dimanche
Colour process engraving, c.1900

Huard specialised in provincials at home and in Paris. His archetypal small town was 'Pavigny-le-Gras', and he had an eye and ear for reaction: 'Tout ce que vous voudrez, mais sous l'Empire les trains n'avaient pas de ces retards' (*Province*, 1902). A Norman, he said that had he not been Joan of Arc he would surely have been English.

problems of cognition and in the generation of meaning, which raised once more the question of limits. Modernism took a great deal of delight in simply, or elaborately, making sense, either through the sort of inscriptions developed by Matisse, for example, or in the kind of photographic palimpsests offered by Atget.

Politically, though, the modernist spirit turned out badly, in that it forswore involvement. Flaubert's Frédéric, at a loss in *Sentimental Education* in the rising of '48, is excusable for there seemed no discernible pattern to events. Delacroix registered something similar in battle pictures which are all confusion. Manet's generation admitted itself dependent on reports with the Truth nowhere, which was no incentive to action, even if such an elderly desperado as Courbet did get mixed up in the destruction of the Vendôme column during the Commune. Humanity was caught up

in social forces apparently beyond control, which gave a melancholy cast to any art which involved reportage: Degas's entertainers, for example, take no obvious pleasure in their work. Man was at the mercy of a larger power than himself, often represented in the cartooning of the period as a dictatorial matriarch, as rigid and inert as Marianne was evanescent. Charles Huard associated such dragons with anachronistic provincial life, although that was Parisian conceit.[4] Man, whatever the causes, was an apathetic creature as easily seen through as misled, and ready for coercion.

The modernist trend climaxed in the Great War, which astonished those who took part and reflected on it not least because of their acquiescence in what appeared to be a huge collective madness. Georges Bernanos's *Journal d'un curé de campagne*, with its range of exemplary women, was written in the aftermath, and on behalf of involvement. He characterised that age as having spoken to itself 'de poilu', as the troops might, in fatalistic terms: 'On répète donc volontiers qu'il ne "faut pas chercher à comprendre".' Not up to us to make sense of it; things are out of our hands.[5] In a paradox typical of his tradition he judged the war less as evidence of prodigious human activity than as a sign of colossal apathy.[6] In Bernanos's diagnosis society had developed quite impersonal imperatives about which he warned when he spoke against the idea of a geometer God, and when he invoked Pasteurian ambitions for an aseptic world. There were also those, *'farceurs'*, who would design and reform society, but always on paper.[7] God was against them too, and might well have been for that garrulous, private art of the inter-war photo-reporters who found small-scale perishable 'worlds' among children, for example, and among the night-people of Paris.

1 Gustave Flaubert, *Madame Bovary*, op. cit., part 3, pp. 365-6.
2 Edgar Germain Hilaire Degas, *Letters*, Bruno Cassirer, Oxford, 1947, translated by Marguerite Kay, p. 179 (an undated letter to Bartholomé).
3 Marcel Proust, op. cit., vol. III, p. 996.
4 Charles Huard, *Toute la province à Paris*, Éditions du Sourire, Paris, c.1900.
5 Georges Bernanos, op. cit., p. 12.
6 Ibid., p. 162.
7 Ibid., pp. 74, 99, 129.

Inwardness

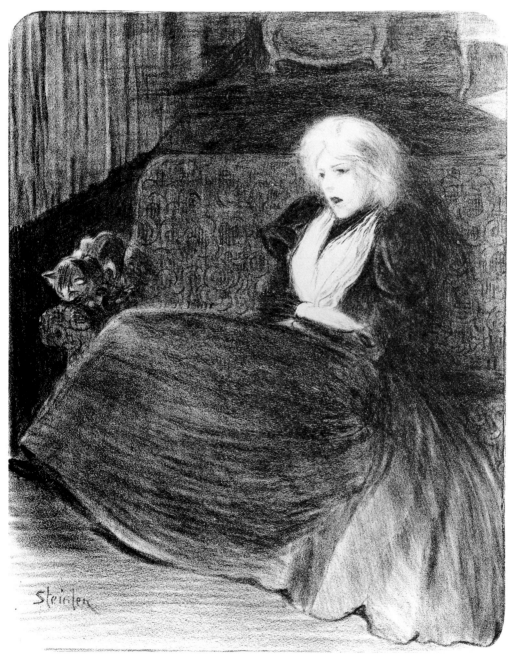

T A Steinlen
Chanson frêle
One of fifteen lithographs from
Chansons de femmes by Paul Delmet
published by Enoch et Cie, Paris,
1899.

Inwardness

Proust explained. It was with reference to Odette de Crécy, loved by Swann. A courtesan, she was practised in the art of being 'at home', which she signalled through flower arrangements apparently half-completed. Her visitors were meant to think of themselves as intimates who were yet at the same time excluded from secrets embodied in the uncompleted flowers or in the figure of an open book. Heavy carpets also made it possible to approach the lady apparently unnoticed as she read in her chair, which added to the romance of the meeting, and implied access to a secret. All that, however, was some time ago, Proust added; the liking for heavily curtained and carpeted rooms was a thing of the past. The passage is from *Within a Budding Grove* of 1919, and Odette's heyday was by then long gone, by thirty years or so.[1]

Reading was a sign of secrets and of inwardness, and it characterises the art of 1900. Courbet, of course, had painted Baudelaire reading *c.* 1847: Baudelaire intent, with one hand outspread and a flamboyant quill in an inkwell on his table. Other Courbet readers fall asleep, or peer at the paper as if mixed up in hard work. There are readers too in Degas in the '70s, although they mean a different kind of business in Degas's strictly practical, explicable view of affairs: Mary Cassatt reads a guide book in the Louvre; a laundress declaims from a letter, and x and y waiting around scan the headlines. If Courbet's readers were involved in hard work and those of Degas immersed in the stream of everyday life, the next generation studied to far deeper purposes. Cézanne's personnel concentrate on texts and games, or they look inward with intensity. His father, reading L'*Événement* with an effort worthy of an early Courbet, looks back to Realism, but such successors as the gardener Vallier develop a detachment and in inwardness unknown before.

In a resonant text based on Cézanne, Kurt Badt remarks on his early feeling for the spiritless and intimidated, for subjects infected with 'la profonde séparation et la grande solitude de l'homme'. His subjects remain solitary but develop 'confidence and poise, a quiet determination'. One of the first to do so was Mme Cézanne in a portrait of around 1877, in which she sits protected by a high padded chair in front of a door, whilst working on a fabric which takes all her attention. It looks like a reminiscence of the kind of close attention at issue in Courbet's picture of grain sifters of 1855, although Cézanne stresses a quality in the woman's concentration rather than in her actions. Badt remarks that the eye of Cézanne portraits beholds rather than looks, that it is aware of the inner heart of things 'beneath the surface which deceives most people.'[2] He might have added that this inner heart is internal, a matter of consciousness, that his sitters keep the ineffable in mind. His old woman with a rosary, painted towards the end of both their lives, looks into a beyond lodged

Paul Cézanne
Old Woman with Rosary, c.1896-9
National Gallery, London
Not in exhibition

Of a woman of seventy from a convent,
taken in by Cézanne as a sort of servant.

deep in her own spirit, with the rosary itself as no more than a reminder of the distracting here-and-now.

The Card-Players, in five versions between 1890-2, are similarly intent, although pre-occupied less by visionary experience than by providence, for they play a game in which chance intervenes. Cézanne surrounds his players with such signs of mere existence as a wine bottle and tobacco pipes, and in the early versions, spectators look on. The game itself is a metaphor for painting: the cards are marked by paint strokes, the elements used by Cézanne in his own game of art. The players, like the artist painting, consult the game for the sake of whatever unpredictable results might come their way. The game, like a game of painting, opens a door into an unknown governed by luck, chance, providence.

The art of the *fin-de-siècle* was intent on secrets, and even on the idea of secrecy itself. It denied Manet's reductivist perception of life as a costume drama and Degas's insistence on business-as-usual. The new generation was to be lost in

E Fréchon
Women reading, c.1900
Royal Photographic Society

thought, musing by the fire as staged by photographer Robert Demachy or reading in
the studio as presented by Henri Matisse. No-one else dwelt so intensely on
inwardness as Cézanne, whose single-mindedness set him apart: Badt judged him
'the pioneer of a new art' to which there was no sequel. Contemporaries tried,
instead, to situate inwardness, to place it, as Maurice Denis did, in a domestic and a
religious context. Proust's Odette is more typical of the age than the old woman with
a rosary. Odette played at secrets, as if inwardness was just another social grace: The
ineffable was too much to be endured and new artists, Matisse, the Cubists, and
Atget in photography, gave consciousness back its playing cards, those
manoeuverable bits and pieces from which 'modernism' would be constituted.

1 Marcel Proust, op. cit., vol. I, pp. 639-40.
2 Kurt Badt, *The Art of Cézanne*, Faber and Faber, London,1965 (originally *Die Kunst Cézannes*,
 1956), especially the section 'Cézanne's Portrayal of People', pp. 181-94.

La femme fatale

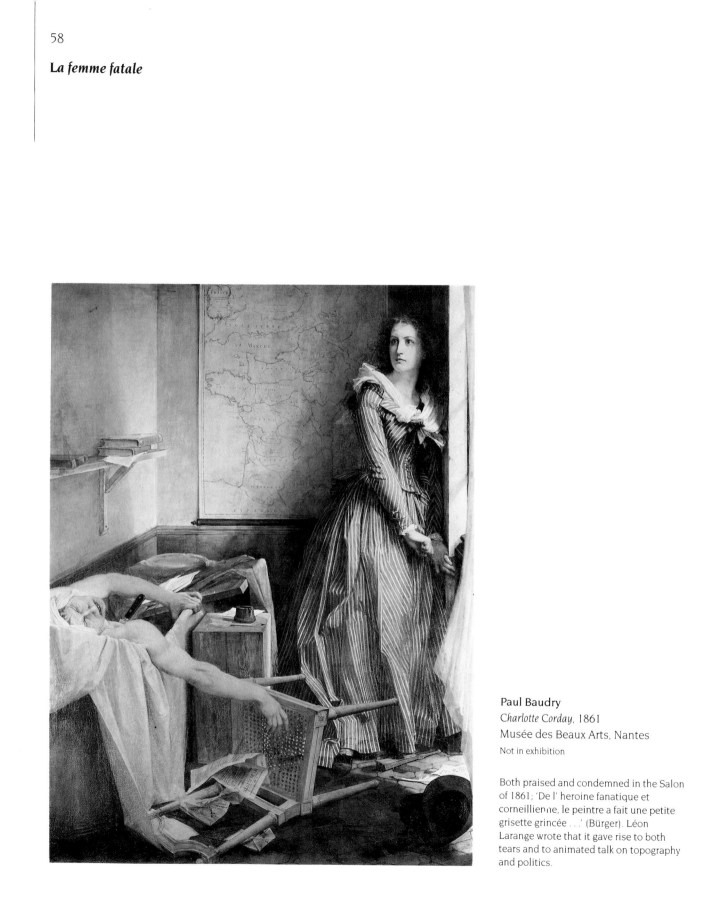

Paul Baudry
Charlotte Corday, 1861
Musée des Beaux Arts, Nantes
Not in exhibition

Both praised and condemned in the Salon
of 1861; 'De l' heroine fanatique et
corneillienne, le peintre a fait une petite
grisette grincée . . .' (Bürger). Léon
Larange wrote that it gave rise to both
tears and to animated talk on topography
and politics.

La *femme fatale*

Marcel loves Albertine, 'that fugitive, cautious, deceitful creature', because she makes him suffer, and because she is loved by others with whom he has to compete. Love, he thinks, might even be dependent on infidelity, on an 'original sin of Woman, a sin which makes us love them, so that, when we forget it, we feel less need of them, and to begin to love again we must begin to suffer again.'[1] Albertine first appears at Balbec as a child of nature, riding on a bicycle. She is meant as a spirit of something, perhaps as a reincarnation of Rude's spirit of war leading the people, for at one point her wind-blown raincoat reminds Marcel of body-armour.[2] At the same time she might also have been his own variant of Marianne, for she is at one and the same time a mistress, a sister, a daughter and a mother, for whose good-night kiss he feels a childish need.[3] Above all, constantly unfaithful, she gives him every opportunity to worry, and it is only in these anxious years that he properly exists; otherwise he is no more than a detached observer.

In an age of disorder the *femme fatale* was unmistakably an imperative, and Marcel organised his life around the pursuit of Albertine. She was one of a long line, some of whom were compellingly represented in French art: in the mid-twelfth century Salome, for instance, danced seductively for Herod on a carved capital in Saint-Etienne, Toulouse. Herod feared John, a just and holy man, but could do nothing against Salome and her mother Herodias, despite his misgivings. He might have been at home in some of the salons described by Flaubert and Proust, such as that of Mme de Villeparisis, analysed in *The Guermantes Way*. Herod does not appear in the art of the Second Empire and after, for in effect he constituted patron and audience. Salome recurs, though, as do Helen of Troy and the Magdalene, especially in the art of Gustave Moreau whose imagination was heavy with the taste of beauty, sin and catastrophe.

Moreau projected a fairyland rich in temptations sumptuous enough to excuse Herod and to explain the Trojan War. Moreau's is a world before the law, in thrall to impulse, and the consequences are splendid and fatal: Pasiphaë, for example, the wife of Minos who fell in love with a bull sent by Poseidon, and had herself disguised as a cow by Daedalus (who then designed the labyrinth to house the resultant Minotaur). Moreau, unknowingly, might have had a political allegory in mind. Both the Minotaur and the head of John the Baptist were the hideous consequences of impulsive self-indulgent moments: Herod, promising, had meant to reward the girl certainly, though not to that degree; and Minos should have done his duty in the first place and sacrificed the bull sent by Poseidon.

The *femme fatale* was irresistible not merely because of the beauty of her person but because she was also at one with nature. Moreau's ivory-skinned sirens fade into

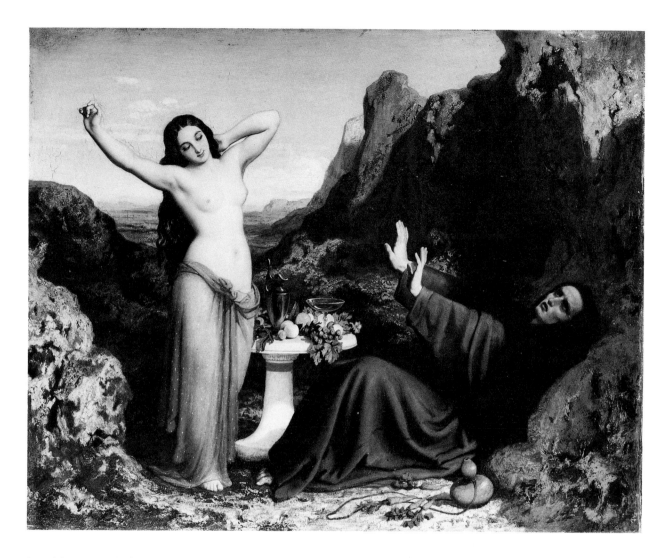

liquid draperies which might have been drawn from the ocean, and the walls of Troy return to earth and sea. Moreau might have been working with Michelet to hand, for in *La Mer* (1861) earth, sea and sky all constitute an extensive ocean or infinite which speaks to the soul. Michelet's ocean also meant life and immortality through eternal metamorphosis, and Moreau's tableaux are fecund with decay around those deadly women from whom everything follows.[4]

The *femme fatale* flourished from mid-century. She was a contemporary of Marianne who might have been Salome herself, freed perhaps from the iron hand of Herodias. There were formidable precursors but they were principled, and activists in their own right. There was, for example, Charlotte Corday, slayer of Marat, painted famously by Paul Baudry in 1860. Michelet told her story in his book on the women of the Revolution; how she took the knife from under her scarf and plunged it up to the hilt in Marat's chest. Before dying he could only utter, 'A moi, ma chère amie'. In love to the bitter end. In Baudry's picture, which was one of the talking points of the Salon of 1861, the beautiful heroine, described by Michelet as turned to stone, stands backed by a map of France, on whose behalf she had acted. Charlotte Corday, guillotined in

D L Papety
Temptation of St Hilarion, 1843-4
Wallace Collection
Not in exhibition

A (surprisingly) clean-shaven follower of St Anthony Abbot, tempted in the Egyptian desert.

1793, was praised to the skies in a poem by André Chénier, guillotined in 1794. In Chénier's reading of events, thought had been enslaved in a land where hypocrisy ruled. In this cesspit it took a woman, 'belle, jeune, brillante', to do what should have been a man's job. Chénier's men were no more than 'eunuques vils, troupeau lâche et sans âme', fit only to mouth excuses, too debilitated to bear arms on behalf of virtue. She was a reincarnation of Clytemnestra, wife and slayer of Agamemnon returned from the Trojan Wars, as intricately described by Aeschylus and pictured in action by P. N. Guérin.

Racine's heroines, who gave Proust so much to think about, tempted no-one and came to their own disastrous decisions. The author, in love with Albertine, imagined himself as Phaedra, who couldn't help but fall in love with Hippolytus, the innocent boy and son of the missing Theseus. Hippolytus was the type of the *femme fatale*, a beautiful innocent whose destiny it was to drive the soulful to destruction.

1 Marcel Proust, op. cit., vol. III, p. 147.
2 Ibid., p. 498.
3 Ibid., p. 107.
4 Jules Michelet, *La Mer*, op. cit., ch. VI, 'La renaissance du coeur et de la fraternité'.

Paris délivré par son peuple,
Pamphlet cover, 1944.

Credited to Pierre Boucher, with François
Rude's head of *Le Génie de la Patrie* in the
background.

Ferdinand and Sophie, Robinson and Madelon found *La Belle France* as a ship in a fairground sometime in the late 1920s, towards the end of Louis-Ferdinand Céline's *Journey to the End of the Night.* It had been built out of plywood by the photographer, and the name was written on the fake life-belts. They stood on the bridge, gazing straight ahead, 'defying the future'.[1] They had just come from the *Stand of All Nations,* which was a shooting alley centred on a bobbing egg. Ferdinand, Céline's hero, had experience of patriotism during the Great War, some of which he had spent as a casualty in hospital among other incurables. There they were drilled in patriotism: 'France has put her trust in you, my friends – like a woman, like the most beautiful of women!'[2] Sergeant Brandelore, with his perforated guts a veteran of the clinics, had learned how to cope: 'if a doctor or nurse was passing, between two fits of choking Brandelore would cry out "Victory! Victory! It shall be ours!" '[3] Lola, a sentimental American woman who distributed apple fritters to hospitals, also thought of France as 'a sort of chivalrous entity . . . at present grievously wounded and for that very reason extremely exciting.'[4]

Céline was not irrefutably the voice of France, but the *Journey* was popular internationally, and with its wealth of fakery, spitting and disgusting smells became a model for literature in the 1950s. Speaking through Ferdinand, he found material enough for complaint. In the war he was up to his neck in reality, or engaged in something which he likened to Aztec human sacrifice presided over by a priesthood of French generals.[5] He couldn't square the idea of killing with love of country, and he blamed the Revolution for the inauguration of patriot armies: 'Danton wasn't eloquent for fun. A few hoarse roars, loud enough for one to be able to hear them still, and he had the people under arms in an instant.'[6] And there was Society, represented by Proust's account, 'that vacuum full of phantom desires, of uncertain fools always awaiting their Watteaus, irresolute, smut-fingered seekers after unlikely isles of amorous enchantment' – Watteau's Cythera, most likely.[7] The People were no better, despite Sergeant Brandelore's good sense. Impressionable, easily hoodwinked, Ferdinand saw them often at the *Moronic* cinema. Parapine, a Polish wiseacre and medical man like Ferdinand, saw the cinema as 'that new little clerk of our dreams', which could be bought or hired for an hour or two, like a whore.[8] Modern life was a peep-show: 'Nowadays public lavatories go in for *décor,* and so does the slaughter-house and the pawn-shop too – just to keep you amused and distract you, and let you forget your fate.'[9] The very stuff of life was disgusting, and in a *tour de force* over six paragraphs Ferdinand, who wandered, described 'tumultuous company' in a vast collective gents under the streets of New York.

Ferdinand may have been meant as a fifth-columnist by Céline, for he enters as

Robert Doisneau
Concierge with spectacles, rue Jacob, 1945
Collection of the artist

Ferdinand Bardamu with a very jaundiced account of the race as 'only that great heap of worm-eaten sods like me, bleary, shivering and lousy, who, coming defeated from the four corners of the earth, have ended up here escaping from hunger, illness, pestilence and cold. They couldn't go further because of the sea. That's your France, and those are your Frenchmen.' Which is to say, with one or two reservations, that Céline's France is Utopia, an ultimate destination. A line or two earlier he had quoted from *Le Temps* à propos President Poincaré opening a show of lap dogs. In Céline's arrangement there was a false France which lacked imagination and spirit, and dealt in lap dogs and patriotism well behind the lines. The true France was exuberant and inventive, and certainly not to be found in any deep-lying ineffable spirit of people and place. Céline was, as Perec would be in the 1970's, good at lists, dazzling accumulations of detail. Fairgrounds were his forte, with mechanical music

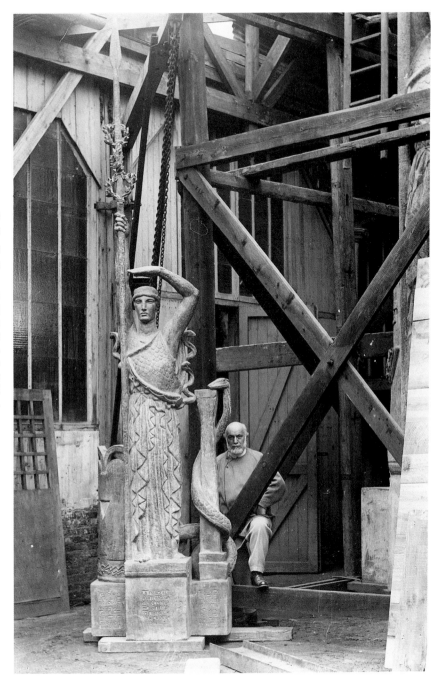

E A Bourdelle
The artist with *La France*, c.1925
Musée Bourdelle
Not in exhibition

Bourdelle was asked to design a colossal statue, measuring 40 metres from ground level to the tip of its spear, to commemorate the entry of the USA into the war. The statue was to be placed in front of a tower of 100 metres topped by a beacon, sited on the Point de Grave. The tower absorbed all the funds available and the statue was never completed.

and wooden horses, fake motorcars and unscenic railways, an unbearded woman, an ungilded organ and a Strong Man without biceps and not from Marseilles: 'Paradise'.[10] Fakery was there ostensibly to be decried, but he loved the Cockney odalisques who played in the intervals at the *Moronic*. Defined by the patriots and by the company he kept as an outsider, Céline's Ferdinand was free to invent and to discern a preferable France which got by in the intervals and under cover, and in the process practically wrote the programme for French inter-war photography: a

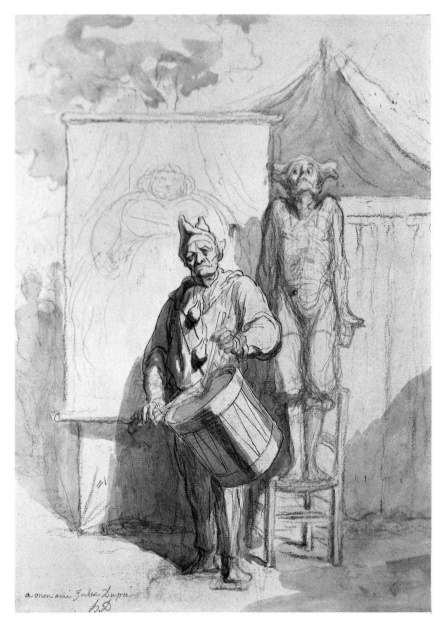

Honoré Daumier
The Side-show, c.1865
Burrell Collection

beautiful fishing scene, for example, an idyll by the Seine where nothing was ever caught, but everything sensed.[11] The France he brought into being, or gave voice to, was manipulatable, portable, like a game in which anything might be invented and imagined, even if not for long. It was a way of escaping from the Aztec gods who ran the official side of things. What was wrong with New York? There was plenty of human life there, as the gargantuan lavatory-scene showed. But it lacked *concierges* without whom the spirit languished: 'Without a *concierge* you don't get anything that bites, harms, cuts, maddens and obsesses and adds something positive to the general stock of hate in the world, illuminating it with a thousand vivid details.'[12]

Céline imagined modern city life as, preferably, an agitated drama played against rapidly changing improvised screens. His men were 'nothing but packages of warm and rotten tripes' moving among the smell of cooking brussels sprouts and old cigarette ends, but those reminders of mortality, on which the war had insisted, gave point to improvisation and spectacle. Céline wrote out the full script in an entertainment for which it might be said that Léger did the *décors*, as the showmen might have wished, free from the reek of those dumps and boiling sprouts. And when Antoine Bourdelle imagined *La France* in the 1920s as an athletic heroine, beyond reproach, a modern Olympian looking to a perfectly arranged future, part of the past which she was meant to put behind her was the small world of b.o., old tin cans and alveolar pyorrhoea detailed by Céline. He insisted on the details; they offset and enhanced spectacle and artifice, distractions which really mattered, such as an African sunset which he introduced as a recurrent tragedy, '. . . like a vast assassination of the sun . . . an incredible piece of tomfoolery.'[13] Life, that is, was nothing without a stage, an impresario and a scriptwriter who might make it into fit material to amaze that audience in the *Moronic*. Transformation was of the essence, even if it did feature the motherland as a plywood ship on a fairground.

1 Louis-Ferdinand Céline, op. cit., p. 517.
2 Ibid., p. 87.
3 Ibid., p. 91.
4 Ibid., p. 50.
5 Ibid., p. 34.
6 Ibid., p. 69.
7 Ibid., p. 73.
8 Ibid., p. 374.
9 Ibid., p. 374.
10 Ibid., p. 329.
11 Ibid., p. 304.
12 Ibid., p. 223.
13 Ibid., p. 178.

Post-modernist fragments

Jean Hélion.
Nude and Flower Pots, 1947
Musée National d'Art Moderne,
Centre Georges Pompidou, Paris

Hélion had the most literate
support of any French painter.
Francis Ponge described him
working in a sort of disused
gymnasium with towels, rugs,
umbrellas and shoes attached to
the walls. Ponge judged his art to
be at once both monumental and
trivial, charmless and tasteless,
although hypnotic: Absurd
Realism.

Post-modernist fragments

What became of Marianne, *La Liberté* and *La France*? In the 1950s an old Marianne from a town hall appeared with some plaster casts, large vases and three alabaster pyramids along with two pages of '30s bric-a-brac and some Pompeiian postcards, c.1900, in the studio of the fashionable painter Hutting, subject of the ninth chapter in George Perec's *La Vie mode d'emploi* (1978). In chapter 95 Bartholdi's statue of Liberty, begun in 1883 in the foundry of Monduit et Béchet, 25 rue de Chazelles, is remembered with reference to the development of the rue Simon-Crubellier. The same statue crops up in the curriculum vitae of Grace Twinker, 'Twinkie', who at the age of sixteen had figured as Liberty in burlesque, shortly after the statue was installed (ch. 55). *La France*, in the Françoise version established by Proust, walks on as a Burgundian cook, Gertrude, successfully opposed to a 'designer' kitchen lay-out in the home of Mme Moreau, a triumphant business-woman (ch. 65). In the dining room in the same house Cézanne's *Card-players* are recreated as a cigarette box (ch. 71).[1]

Georges Perec, who died in 1982, was the Balzac and Flaubert of post-modernism, and his guide to the condition is his thoroughly-indexed *La Vie mode d'emploi*. French, and any other, art in the 1970s developed an oblique, mediated manner, rich in textual additions and in references to tradition. It was an art which had been a long time in the making and it drew on, for instance, the semiological work of Roland Barthes, who, with his books on Racine and Michelet, was one of the great re-readers of French literature. Barthes construed Racine in abstract, almost structuralist terms, as a writer interested in relationships, rather than in character and in suffering. In a typical formulation, 'A has complete power over B, and A loves B, who does not love A.' Racine was a geometer faced by intractable problems. Barthes, writing in the 1950s, recognised in Racine a very definite character with a structured imagination.[2] Before then he had mapped Michelet's character, as expressed in his writing, in systematic, if more metaphoric, terms: 'For Michelet, Blood is the cardinal substance of History . . . What Michelet inveterately sees in Woman is Blood.'[3] Perec denied Barthes's view of humanity, and at length.

Perec was a student of hopeless situations, and wrote of them with some bitterness in the 1960s in *Les Choses* (1965), his first novel. At one point his heroine exhausts herself in Tunisia teaching, in accordance with the syllabus, the hidden beauties of Malherbe and Racine, to students larger than herself who did not yet know how to write.[4] In the 1970s, though, he appeared as a dispassionate scrutineer interested in life stories and routines which very definitely made no sort of sense. Things were redeemed for Perec by words. His characters try to make good, hopefully and much in the manner of Flaubert's M. Arnoux, and in the process switch names

and identities. Rémi Rorschash, typically, begins in Marseilles, becomes an American-style comic, and forms a dance group, 'Albert Préfleury et ses Joyeux Pioupious (foot-soldiers)', and another and another through to 'Alberto Sforzi et ses Gondoliers'. Then a world tour as an impresario in charge of an acrobat who refuses to descend from his trapeze, before dealing unsuccessfully in cowrie shells (*Cyproea turdus*) in West Africa, where his financial coup is forestalled by one Schlendrian. Finally he writes novels and memoirs, and makes money mysteriously in the war. Rorschash is one of many, equalled, for example, by Joy Slowburn, *née* Ingeborg Skrifter, married to a Korean War deserter, Blunt Stanley, blackmailed by a Filipino chauffeur, Carlos originally Aurelio Lopez, able to raise Mephistopheles at will (eighty-two times in two years), and patron of a black opera star keen to sing Desdemona, which she does with a white Othello, for Ingeborg is a clairvoyant with influence. Perec's characters listen to the radio for the sake of its (once) exotic stations: 'Hilversum, Sottens, Allouis, Vatican, Kerguélen, Monte Ceneri, Bergen, Tromsö, Bari . . .'. Or they look for phantom tribes known to the Malays as Anadalams or Kubus, on which they might write elaborately-titled scholarly articles. Plus Lady Forthright and Juan-Marie Salinas-Lukasiewicz, the South American tinned beer magnate, Colombia to Tierra del Fuego . . . and thousands more, for *La Vie* took nine years of research.

What does it mean? Why should it come up here? It is meant to be interpreted, and chapter 55, for example, reads like a dour version of *Sentimental Education*, with the loved one showing him the door after an interval of forty years. In a postscript he acknowledges derivations from thirty authors, including himself, and this might just be a key to the whole thing, signalled by his interest in such puzzle-makers as Gaspard Winckler. That is: *La Vie mode d'emploi* ought to be read with attention, and its motto is from Jules Verne: 'Regarde de tous tes yeux, regarde.' But with its six sections and ninety-nine chapters, plus indexes, it is too much to take in, which might be Perec's theme. Perec is good on 'research', one of the shibboleths of post-modern times, and his personnel undertake enquiries which might involve, for example, scanning all the newspapers published in Europe over a five-year period. Then there are problems of tabulation, of press cuttings and old luggage labels. Messages come in during the Liberation: 'The Archdeacon is a past-master in the art of Japanese billiards.' His people read the newspapers with immense attention and no apparent understanding, and become specialists in, for example, animated watches, which also allows Perec to describe intimate human functions in terms of automation; this representation of life as puppetry is very characteristic of the art of the '80s.

Post-modernist fragments

Fernand Léger
Two Women holding Flowers, 1954
Tate Gallery
Not in exhibition

Perec is both diverted by and paranoid with respect to information, the real stuff of post-modern life. His world is a museum richly endowed and imperfectly catalogued, featuring Marianne as a memento, Liberty as an entry in a guide book, and Françoise as an anecdote. Barthes insisted, at least, on a structuring human consciousness, but in Perec's elaborate microcosm there is just a plethora of data, for which his figure is a pin-board scaled with memos, photographs and timetables. His subjects escape

Arman.
Venus of the Shaving Brushes, 1969
Tate Gallery

Arman has favoured cement, polyester, plexiglass and quotidien items, burnt, exploded, sawn into pieces or assembled in echelon.

Not in exhibition

into toy-making and miniaturism, or they become specialists or collectors of cards and their phrases, for example, 'Madeleine Proust "Souvenirs" '. The nation is ludicrously diminished in the information ocean: the director of CATMA (Compagnie des Transports Maritimes) meaning to lecture on an official trip to the Sahara, 'Mzab aux mille couleurs', suffers an exchange of slides, ending up with 'Splendeurs et misères de la scène française', starring Robert Lamoureux in Sacha Guitry's *Faisons un*

Post-modernist fragments

rêve. Old France enters as an epitaph for a student, Grégoire Simpson, failed cataloguer and researcher who had once reminisced about the ecstasy of childhood festivals in a red, white and blue costume prepared by his mother.

1 Georges Perec, *La Vie mode d'emploi*, Hachette, Paris, 1978. Perec's novel, the result of nine years of work, won the Prix Médicis. It is indexed and annotated over 100 pages.
2 Roland Barthes, *Sur Racine*, Éditions du Seuil, Paris, 1979, p. 29 (previously published by Éditions du Seuil in the collection *Pierres Vives*, 1963).
3 Roland Barthes, op. cit., p. 119 and 147 (originally published by Éditions du Seuil, Paris, 1957).
4 Georges Perec, *Les Choses*, René Julliard, Paris, 1987, p. 116 (originally published 1965, winner of the Prix Renaudot).

Survivals

E-V Luminais
*Abduction of a woman by Norsemen in the
ninth century*, 1896
Musée d'Art et d'Archéologie,
Moulins

From Nantes, Luminais painted Vendée
scenes before becoming the most
successful of all history painters: Gaul,
Merovingian France and the Middle Ages.

Pompier painting is a difficulty in the art of the nineteenth century. The term referred to ceremony and to convention, and had pejorative overtones. Pompier painting was uninspired, and it came in bulk. What exactly was wrong with it? *Équivoques*, one of the major exhibitions of the 1970s, at the Musée des Arts Decoratifs, Paris (1973), mulled it over and decided against a wholesale write-off, whilst admitting to limitations. The weakness stemmed from an anxiety to please a public with well-known expectations. It was a state art patronised by ministers who knew no more about it than 'des cochers de fiacre', who delegated to the professionals who in turn looked after their own interests. Critics complained, apocalyptically, about the industrialisation of inspiration, 10 to 4 sublimity, and on bowdlerisation in the interests of family viewing. It was noted that painting shifted its terms in keeping with such life-style factors as the size of apartments, and that it might as well be quoted in the Bourse between sugar and coffee. Disenchanted observers were inspired by the collapse in values.

There were shortcomings. Not lacking ambition, the pompiers set out to keep great themes in being: from the early history of France, from Racine, Shakespeare and from the classics. Theirs was a perfected art, in detail and in full colour: 'horriblement ressemblant' said Cézanne, quoted by François Mathey in an unsparing introduction to *Équivoques*. Delacroix, of course, had similar ambitions; at least he explored in history and painted on a large, public, scale. Yet Delacroix fits with difficulty into the pompier category, and the major difference is that his work is more rough-hewn than that of the pompier artists. Courbet, too, had ambitions although he worked within a raw provincial idiom which saved him from damnation. Ingres, with such major official pictures to his credit as *The Vow of Louis* XIII (1824), looks like one of the originary pompiers, but he often escapes perhaps because of his synaesthetic excesses, his taste for edible, aromatic tints. The pompier proper gave a full but not extravagant account of life in Merovingian France or of the campaigns of Napoleon. Ingres's taste, by contrast, knew no bounds, and Delacroix painted like Rubens incensed.[1]

Pompier art comes in for criticism, and even such advocates as the *Équivoques* team recommend it apologetically as poor painting which somehow makes the grade, puzzlingly, and despite being the preferred art of a *Bouvard and Pécuchet* audience. As painting, that is, it fails to match up to the extremism of Degas, Cézanne and the others; but that may be to misjudge it, for the major pompier pieces were never prime works, in the way that might apply to a painting by Cézanne; they were originals as that term might be used in a printing business, originals from which copies were meant to be taken. *Équivoques* illustrates one of the most eerie of

all pompier paintings, Evariste-Vital Luminais's *Les Enervés de Jumièges* (1880), of two youths floating on a wide lake in an upholstered bed: the sons of Clovis II, found guilty of revolt, hamstrung and set adrift to be taken in eventually by the monks of Jumièges. The catalogue quotes Simone de Beauvoir remembering the *Enervés* as one of the impressive images of her childhood, from the cover of *Petit Français illustré*. Photographed and engraved, pompier works were widely known, in monochrome and in miniature, with accompanying texts, illustrating history, the classics, country life and the Bible.

Isolated, pompier paintings disappoint as major art, but they were meant as first appearances in a performance intended to continue in family and in educational milieux. They constituted grounds for debate, reminiscence and enquiry, which might just as well be carried out in front of engraved copy as in front of the real thing. Indeed, the copy as an illustration in tone and line was approachable and manageable which has been one of the abiding points of modern art. The nineteenth

Paul Delaroche

The Execution of Lady Jane Grey, 1833
National Gallery, London
Not in exhibition

She reigned in England for nine days in 1553, until overthrown and executed by Mary I. Delaroche's art was very widely known from 1831 through the engravings of Goupil. 'Springing from a race which is first and foremost literary he did not paint but rather wrote his pictures, and the elements for which we blame him were the very secret of his success.' (Théophile Gautier in L'*Artiste*, 1858).

century, from Goya onwards, preferred a composite, discursive art which would engage its audience rather than impress it into silence. Goya remarks on this or that atrocity and bizarrerie: 'would you believe it?' Delacroix presents himself as a rough painter, as Rubens without the finesse, and as a reader in contemporary fictions which might be identified to the very verse or line. He elicits discussion:which one exactly is Charles le Téméraire in that indecipherable battle of Nancy? And what are those women up to in those shady apartments in Algiers? Delacroix admired Byron, an easily distracted poet if ever there was one, whose great themes are alleviated by doggerel, reminiscence and weather-forecasting. Courbet's *Burial at Ornans* might have been a report for a local newspaper ('Those in attendance included . . .'), as well as a reflection on the resurrection of the body. Courbet was an anthropologist, interested in just where the women stood in relation to the menfolk, and his audience might be expected to cast back for comparable memories. That is: nineteenth-century art was discursive both with respect to provincial funeral arrangements and, for example, the life of the Minotaur, half-brother to Ariadne, as Moreau's audience might have remembered.

Discussion, though, was not only invited, it was facilitated. Art objects, once established, tend towards inertia. Both esteemed and known to be detached from an original context, they attract exegesis which hedges them about, defining the public as an audience which needs to take special steps to be informed. Pompier painting, with its attention to fabrics, botany and table arrangements, placed art within the public domain, made it accessible to a householder's eye. And reproductive processes robbed art of its charisma; an engraved copy, seen with other engraved copies, might be taken in casually, or undaunted by contact with the real thing imposingly presented. The nineteenth century was remarkable for its interest in such processes as lithography and photography which, importantly, promised to lower the dignity of art. In photography there was no original, and the artist could easily be mistaken for an artisan. Whatever photography was meant to achieve it liberated the pioneers, allowing them to make their own unsteady versions of great art, as it were under cover and with whatever materials came to hand. It is as if orthodoxy was stifling, as if such great subjects as Inwardness and History could only be considered covertly, or in passing, or via some plain idiom: Cézanne's patient assemblage, Delacroix's hasty manner. Once an adequate form was established and recognised in the public domain its useful days were over. Popular media became especially important within this context, for they were relatively unsupervised and uninhibited by the kind of wariness prevalent in art.

Some of the major, national subjects identified in this exhibition flourish not in

J-C Servais (drawing) and Dewamme
(writing).
Drawing from the front cover of their
Tendre Violette: Malmaison, Casterman,
1984.

In *Malmaison* Tendre Violette, 'une rebelle
qui aime par-dessus tout la liberté', is
embroiled in eighty-two pages of passion,
herbal remedies and black magic, all in
archaic countryside. The louts involved in
this frame invite the heroine to drink to
the restoration of her home in the woods,
but are immediately got shot of by
Bourguignon, the hero, a mason and
accordionist of no known parentage.

the gallery art of the 1980s, which has become an exotic trans-national matter, but in narrative illustration, for *bandes dessinées* in particular. Marianne, for example, survives variously transformed in the art of Jean-Claude Servais into Tendre Violette, a peasant written out by Dewamme for Casterman.[2] Their Marianne is a successor to George Sand's heroine of the same name (1876)[3] and to Maurice Pagnol's Angèle, (1934) in that she exists in a 'long ago' when history was flavoursome. Ultimately they descend from Flaubert's Louise, the nature girl who graces *Sentimental Education*. Sand's Marianne inhabited the 1820s when a city man might be expected to select his bride. A child of nature, and astute, she won through finally to the man of her choice, a typically vapid older hero who ought to have known better in the first place. Pagnol's Angèle, illustrated by Servais, also appears to live in a bygone world when the men of Marseilles (Marsiale) could be relied on to behave badly. Louis, a slicker who might have been read a mile off, wins her heart, and she ends up on the game in the metropolis. Saturnin, a peasant of no known parentage (a son of the land), finishes Louis with a sickle and reclaims the girl and her child for the true country, where she ends by marrying a man of the mountains, another vapid hero for whom everything is done by unrewarded others. Angèle came originally from a tale by Jean

Giono, U*n de Baumugnes*, converted into a filmscript by Pagnol in 1934. Servais's heroine, a limber beauty, lives among the kind of devils who disfigure Angèle's world: witches and sullen outsiders.

Marianne and her reincarnations may have been children of nature, but they were no leaders of men; that role, inaugurated by the spirit of war exhorting the volunteers of '92, survived in Reiser's Jeanine, star of the satirical magazine *Hara-kiri* between 1976 and 1982: 'O.K., je suis toujours la plus belle.' Jeanine, a bad single parent, represents unreconstructed vivacity and self-indulgence, and exists as a foil to a wide range of inadequate contemporary men: financial managers, headmasters and social workers, all of whom imagine that the rules are meant to be kept. Jeanine fights age, decay, and infestation in the face of such apparatchiks and by the side of short-term brutes only interested in one thing, but generally too slow-witted to be any sort of match for her rage and impetuosity. Her men, poorly shaven would-be toughs, labour under illusions as to the role of women in the home, but she eats from tins and despises filters, which allows for exuberant smoker's coughing, establishing her as even more of a presence. She, too, is a kind of France, admired by a Breton at one point as a spirit of place, with her buttocks hard as granite and her aroma of rotten

Reiser
O.K., *je suis toujours la plus belle*!
From *Jeanine*, published by Albin
Michel, 1987.

The drawings originally appeared in *Hara-kiri*. Jeanine, a heroine of self-indulgence, is an equal to any of the inventions of Daumier and Gavarni.

prawns. But she might more accurately be placed with Liberty on the barricades, surrounded by much the same cast as Delacroix introduced, although faced by other dangers entirely: the breakdown of the family, sheer weight of circumstance and the omnipresence of a system that would lay down the law. Jeanine is in the tradition, Liberty and the spirit of the place together, but under cover, a far cry from the soigné world of '80s art.[4]

1 See the catalogue *Ingres*, Petit Palais, Paris, 1967-8. For a colossal survey of Les Pompiers, see Cécile Ritzenhalter, *L'École des Beaux Arts du XIX siècle, Les Pompiers*, Editions Mayer, Paris, 1987.
2 Servais-Dewamme, *Tendre Violette*, Casterman, Paris, 1982, and, by the same authors and publisher, *Tendre Violette: Malmaison*, 1984, and *Tendre Violette: l'Alsacien*, 1986.
3 George Sand, *Marianne*, translated by Siân Miles, Methuen, London, 1987.
4 Reiser, *Jeanine*, Éditions Albin Michel, S.A., Paris, 1987. *Jeanine* is one of thirteen collections of Reiser's work published by Albin Michel.

The Survival of the Genres

Alain Sayag

Willy Ronis
Provençal Nude: Marie-Anne at Gordes,
summer 1949
Collection of the artist

The Survival of the Genres

In France, large-scale history painting went out with Manet. That was the end of the great myths which had been the staple diet of painting for centuries. The Muses were struck dumb and made way for the scintillating charms of landscape, followed by the increasingly abstruse rhetoric of painters turned theoreticians. It is an often-told tale of woe, and Jean Clair has given a lucid and devastating account of it in his pessimistic *Considérations sur l'état des Beaux Arts*. Rather than repeat his indictment of modern art as identified with revolution, I shall insist, less ambitiously, on the permanence of ideological structures which, through all the upheavals of the past century, have persisted right down to our own time.

At the turn of the century, the great traditional divisions of painting were falling into disuse: history painting, portraiture, genre painting, landscape and still-life were merging into a practice of painting which made its distinctions in other ways. What seemed much more important was the place of the work in a specific socio-economic circuit – even though the distinctions involved were already more or less covered by the system of genres. The appearance of alternative ways of making an artistic career was nothing new in itself: even in the nineteenth century it was not necessary to work through the Academy in order to be a financial success. Even so, the Institut de France, the Salon, and the decorations given to recognised artists, survived as intellectual as well as moral benchmarks. And this social hierarchy was paralleled by a consensus view of the 'values' which were held by every artist, from the acknowledged master to the apprentice dauber, from the *Directeur des Beaux-Arts* to the provincial Cousin Pons.

After the First World War, all this changed: the Beaux-Arts system, which had been in crisis for thirty years or more, was swept away for good. The Salon had been undermined from within by painters who disputed the right of the Institut de France to rule over the whole of artistic life, and from without by the art world as a whole, with its demand for Salons with 'no jury, no prizes'; it was now more-or-less entirely irrelevant. Above all, however, the rise of new aesthetic attitudes, radical enough to call into question the pursuit of technical and formal excellence, sounded the death knell of the Beaux-Arts system as it had functioned throughout the nineteenth century. Henceforward the painter's subjectivity imposed itself as the only criterion by which the work could be judged, its only yardstick and its only purpose. The fine arts were now the visual arts, *les Arts Plastiques*, an international phenomenon as oblivious of the frontiers between genres as of the 'geographical accidents' represented by national Schools.

Nevertheless, painting is by no means exclusively self-referential: there have been numerous endeavours to revive the ancient categories and terms. This applies not only to those who refuse to have any truck with modernism, like Poughéon, Raphaël

Delorme or Courmes – artists whose large and ambitious decorative schemes are now being discovered with delight, at least outside the museum world – but also to a number of more 'acceptable' painters, such as Roger de La Fresnaye and Georges Braque. And it would be disingenuous to see this return to genre-painting or the still-life (as some art-historians do) as a desire to pander to 'American collectors put up to it by Paul Rosenberg'.[1]

Ultimately, however, these are isolated endeavours, and they do not amount to much. It is in other areas, such as photography, that the old genres have best maintained their validity. Thus, photographic reportage is nothing more or less than the traditional genre-scene. The terms used by Diderot, in his *Salon de 1765*, to describe Greuze's *Girl Weeping over her Dead Bird*, *The Spoilt Child*, *The Ingrate Son* or *The Son Punished*, might be applied word for word to a photograph by Henri Cartier-Bresson, Willie Ronis or Robert Doisneau: the photographic reporter 'carries his talent', as Diderot puts it, 'everywhere, amid the throng of the people, into churches, markets, promenades and houses, along the streets . . . collecting passions, characters, expressions . . . to endow art with morals and to link events in a sequence from which it would be easy to write a novel.'[2]

Greuze, so Diderot tells us, is skilful at identifying, with a few deft touches, the essential moment in the little drama that he is staging for us. In the same way, Cartier-Bresson defines a successful photograph as 'the simultaneous recognition, in a fraction of a second, of the significance of an event as well as of a precise organisation of forms which give that event its proper expression'.[3]

The reasons for this phenomenon of continuity are many. There are vestiges of a craft tradition, the consequences of the material constraints to which the photographic reporter is more subject than any other. More simply, however, it can be seen as a code of representation of the world which retains its validity whatever may be the technique employed.

But it is worth going one step further and asking oneself why it is that every time photography aspires to be something more than a trade – an artisan's art – it abandons genre and the anecdote for the realm of fiction. At the turn of the century, the leading lights of the Pictorialist movement – such as Demachy, and a number of less celebrated figures such as the Comte de Dalmas – staged quantities of 'historical' tableaux. Nowadays, in the world of image-processing and distribution, silver salts are losing ground to electronics. Photography is turning in the direction of art and creating a world of the imagination which affords great scope for more-or-less precise mythological references.

Between the return to painterly professionalism pure and simple, as practised by painters such as Balthus, Theimer or Rustin, and the last gasps of a bloodless

modernism, is there no other path? Photography, by breaking the representational taboo and becoming receptive to the world of the imagination – something that seems not only discordant but entirely incompatible 'with photographic sharpness and objectivity' – has placed itself in the centre of the contemporary debate. It opens the way for the return of those illusions 'which are necessary and essential for the happiness and perfection of humanity'.[4]

Translated from the French by David Britt

1 *La Collection du Musée National d'Art Moderne*, Centre Georges Pompidou, Paris, 1986, p.101
2 Diderot, *Oeuvres Complètes, volume* 13, *Critique* I: *Salon de 1765* Hermann, Paris, 1975, pp. 177-178
3 Henri Cartier-Bresson, 'The Decisive Moment', in Peninah R. Petruck, *The Camera Viewed, Writings on Twentieth-Century Photography*, Dutton, New York, 1979, vol. 2, p. 23
4 Jean Clair, *Considérations sur l'état des Beaux-Arts, critique de la modernité*, Gallimard, Paris, 1983, p.173

Daughters of the Century

Isabelle Julia

Thomas Couture
A *Vow to the Madonna*, 1856
Musée départemental de l'Oise,
Beauvais

Mothers, lovers, saints, courtesans; conquering heroines, victims, redeemers; *femmes fatales* and society ladies; *grisettes, lorettes, cocottes*; Parisian and provincial, town-bred and country-bred; Alsaciennes or Bretonnes; embodiments of the Nation or embodiments of Vice: the feminine image in nineteenth-century culture is a thing of endless variety. Between 1789 and 1914, French society underwent a rapid and profound transformation, and these changes were expressed in an unprecedented variety of images of womanhood.

It was a niche, in art as in the world in general, which had remained rather a confined one ever since the Renaissance. The society was aristocratic, and thus heavily reliant on the continuity of the male line; the Academy of Painting ruled supreme, with its laws of decorum and its codification of artistic genres; and so the female figure had a strictly limited, conventional, conformist and idealised role to play. Women were goddesses and nymphs (or Virgin and Saints) in history painting; queens or princesses in portrait painting; embodiments of handicrafts or peasant life in genre painting.

Then, for nearly a hundred years, France was overtaken by a series of social and aesthetic revolutions, each more shattering than the last. Both ideologically and formally, artists were drawn into a quest, the course of which is exemplified with particular richness and vividness in the constant transformations of the image of womanhood.

The enormous volume of images bequeathed to us by the nineteenth century rewards careful study. There was never a sudden and complete break with the principles that had held good since the Renaissance: instead, there was a welter of subjects, themes and compositional formulas which had been diverted from their traditional meaning, or emptied of their primary content, or underpinned by new ideals, or revitalised by a new state of mind, or carried to a quintessential extreme.

History painting continued, taking its subjects as before from myth, from the ancient world, and from biblical or sacred history; but its choice of material also began to reflect the age. New allegorical themes appeared, including personifications of France, *la Patrie*, the Nation. The portrait, which was the favourite genre of the bourgeoisie, and the mirror of its newly established social status, affords enough evidence in itself to enable us to trace the evolution of art in the nineteenth century.

The dominant characteristic of the century as a whole is the proliferation of forms of representation. An unprecedented wealth of images, generated by the invention of photography and by the mass-production of prints, coincided with a relaxation of the boundaries between genres. Continuity, change and transmutation formed a rich and rapidly shifting blend, and the resulting imagery underwent a succession of radical

changes up to the moment when the aesthetic debate came to concern itself not with the image of woman but with painting itself.

Venus or shepherdess: these were the images of womanhood with which Boucher, Fragonard, Pigalle and Houdon delighted their public. How and why did this come to be so? When nineteenth-century artists kept to the traditional themes of history painting, how profoundly did they transform them? During our period, many painters and sculptors followed the example of their great Renaissance and classical predecessors in depicting goddesses and nymphs. But Gérard's *Psyche and Cupid* (1798), Chassériau's *Venus Anadyomene* (1838), Ingres's *La Source* (*The Spring*, 1856), Baudry's *The Pearl* (1863), Cabanel's *Venus* (1863), Delaunay's *Diana* (1872), Bouguereau's *The Birth of Venus* (1879), and many more besides, only go to show that a return to the Antique, which might have been possible in the Neoclassical period, was certainly no longer possible several decades later. Ingres's *La Source* was the final masterpiece before the break. Thereafter, although the reference to Raphael lingered on, its content was lost; behind the subjects there was nothing but a pictorial tradition, whereas in the Renaissance and in seventeenth-century classicism there had been an idea. All that counted now was the painter's technical skill: he had no personal vision, no conception in tune with his own age.

Even so, on rare occasions, a threadbare academic theme might take on a new, political significance and acquire new force. Thus, Gérôme chose the moment of the Dreyfus case to represent *Truth Emerging from a Well* (1896, Musée d'Art et d'Archéologie, Moulins). This is no demure damsel waving a mirror but a Fury, shrieking her indignation in the face of error and obscurantism.

Somewhere behind all this pursuit of eternal myths, there lies an unavailing search for a lost golden age, which finds expression in an unprecedented academic perfectionism, and in the evocation of a chilly, hieratic ideal that seems somehow inseparable from the expression of equivocal desires. Cabanel's *Albaydé* (1868) represents the quintessence of those images of womanhood in which remote and beautiful ladies, lost in some cold and vacant reverie, hint at a refined eroticism which makes women into objects of delectation, and which above all – in this work as in those of Bouguereau, Gérôme and many others – endows human beings with a sleek unreality that springs from a physical revulsion against their solid, carnal presence. The very same academic themes could also be treated in a completely different, contemporary, Realist manner, as they were by Courbet in his version of *La Source*, with its outrageously naturalistic view of anatomy (1868), and above all by Manet in *Olympia* (1863). Manet's figure belongs to the great tradition of classical nudes, from Titian to Goya and the odalisques of Ingres; here, however, the eroticism is no longer sensuous but tragic. It comes across as a deliberate break with

expectations, something that has nothing dreamlike about it at all, but which incites the viewer to reflect on the nature of society.

The great classical or barbaric themes – those of Greek myth and those of modern literature, from Shakespeare to Chateaubriand – exerted a powerful attraction on artists, and most particularly on the Romantics. There were many versions of the *femme fatale*, the destroyer of family life and life itself: figures such as Medea, whom Delacroix shows us preparing to commit the most horrific of crimes, the murder of her own children (1838); or the protagonist of A-E Fragonard's *Death of Cassandra* (1840); or Velleda, as seen by Corot or by Maidron (1839); or like their down-to-earth, modern counterpart, Manet's *Nana* (1877), who is no longer a Baudelairean prostitute but a highly contemporary *cocotte* with an elusive, sinister look to her. And as for Woman as Victim: Chassériau's choice of subject matter makes him the leading specialist in this particular view of femininity. His Desdemona, Ariadne and Esther are all sacrificial victims of male desire.

Parallel with all these images of fallen women and immolated lambs – *femmes fatales* and paragons of virtue – there developed a large body of Marian imagery; the dogma of the Immaculate Conception actually dates from 1854. The Virgin Mary, the ultimate emblem of motherhood, represents solace and comfort for those who have sinned, as is shown by Hesse's *The Virgin Interceding for Sinners* (1848) or Couture's *Consolatrix afflictorum* (1856), or Bouguereau's *The Virgin as Consoler* (1877). Certain female saints came to be represented in a dual guise, as conqueror and as consoler: St Genevieve and Joan of Arc (who was not canonised until 1926, but whose iconography was largely a nineteenth-century creation) were both young, both shepherdesses, and both saviours of France; they embody the ideas of defence, guardianship and the rallying of a new nation, a fundamental theme for the period.

Throughout the nineteenth century, the visual expression of the idea of nationhood – that of *la Patrie*, the Republic herself – remained a basic preoccupation for artists who responded to it, more often than not, by reaching for the nearest academic cliché. During the Revolution, it had been second nature to turn to ancient Rome for stereotypes. Gauffier, for example, celebrated the patriotism of the artists' wives donating their jewels to the convention by reverting to the traditional *exemplum virtutis* of *The Generosity of the Roman Women*. The 'Three Glorious Days' (27, 28 and 29 July 1830), which marked the fall of Charles X and, before the advent of constitutional monarchy, briefly revived hopes of a republic, gave new currency to the aesthetic issue of how to represent the Republic as an idea. This problem, which was both a conceptual and a formal one, was brilliantly and forcefully resolved by Delacroix. All the efforts of the others who set out to illustrate the theme – and in the 1831 Salon there were twenty-three artists who drew their inspiration from recent events – faded

into oblivion. One superb woman, the embodiment of victorious Liberty, grasps a tricolor flag, the symbol of the French Republic, and 'guides the people' of Paris. Ideal and modernity – classical norms and elements of realism – combine to create a powerful image whose universality of reference is entirely characteristic of Romanticism (illus. p.10).

One of the first concerns of the provisional government of 1848, immediately after the February rising, was to find a figurative representation of the idea of the Republic for purposes of self-assertion and propaganda. Artists were confronted with the need to give visible shape to an idea. Memories of the great Revolution were still associated in people's minds with the idea of bloodshed, and still provoked a reflex reaction of fear; it was therefore necessary to find an image that would be explanatory, reassuring, moderate, decorous and conciliatory. It seemed obvious that it would have to be a female figure: the image of the Republic merged with that of the nation, *la Patrie*, and with that of the Mother as a shield and inspiration. The Republic was therefore personified in a young woman, beautiful, strong-willed and noble; but she had also to convey the idea of change and renewal and to impart a simple didactic message.

A whole generation of artists took part in the debate: 450 painters, 173 sculptors and 31 engravers entered for the contest held by the government. Only 60 paintings and 26 sculptures have survived to be listed by Marie-Claude Chaudonneret (in her *La Figure de la République, le concours de* 1848, Paris, 1987). Works like that by Cornu (Musée de Besançon) exemplify a Classical approach, concentrating on the figure herself; others, like that of Janet-Lange (Musée Carnavalet, Paris) show modern France enlightening the world, surrounded by all the symbolic bric-à-brac required by her dual role as a rural and an industrial country. From today's viewpoint, the sketch that best conveys the spirit of 1848 is Daumier's *République* (Musée d'Orsay, illus. p.21), a modernised personification of Charity, with a stress on solidarity and brotherhood. Daumier complements the traditional heroic symbolism by adding to it that of learning and education, the great preoccupation and the great achievement of the second half of the nineteenth century. This image is at once ideal, grave and timeless; it transfigures the real in order to create an exemplary model.

Defeat in 1870, and the loss of Alsace-Lorraine, profoundly traumatised the artistic imagination and gave rise to works in which the subject is no longer the form of the commonwealth but France herself. The idea of nationhood evolved in the course of the nineteenth century, in France as in other European countries, and found expression through powerful images such as Meissonier's *Allegory of the Siege of Paris* (1870, Musée d'Orsay) or Doré's *Alsace Afflicted* (1872, Conseil général du Bas-Rhin, Colmar). Allegory here sometimes shades into the genre scene: Raoul Capdevielle's

Rags of Glory (1909, Musée des Augustins, Toulouse) shows us a woman mending huge blue, white and red flags: a symbol of blighted hopes, and of the constant struggle to save *la Patrie*.

Continuity in the use of forms – the return to classical norms, as codified by the Academy, to express the new ideas of nationhood and patriotism – came together with the new and bracing wind of realism to create a feminine image which was at once noble, warlike and sheltering: one of the many faces of nineteenth-century womanhood.

Ingres and his pupils, as well as Chassériau, Courbet, Hébert, Bonnat, Renoir and a host of others, both famous and forgotten, contributed to what Zola called 'a flood of portraiture, rising higher every year, which threatens to take over the whole Salon' ('Mon Salon', *L'Evénement illustré*, 2 May 1868). For artists – especially if they had lofty ambitions – the portrait was a vital lifeline; and it was also the primary outlet for the representation of the female figure. Classified as the second highest in the Academy's hierarchy of genres, portraiture proliferated in chaotic and fascinating profusion throughout the nineteenth century. As the mirror of society, which it depicted with respect at a time when bourgeois ideology was supplanting that of the aristocracy, the portrait was a means by which one could affirm oneself, one's class, one's membership of a social world. In the eighteenth century, Paris had been the capital of elegance and good taste; in the nineteenth, it became the breeding-ground of fashion. People came to Paris to have their portraits painted, just as they came to buy the latest creations of Worth. Full-length, half-length, head and shoulders or face only, alone or with their children, women posed for the artist with every sign of satisfaction

Portraits grew in numbers, but also in size, especially in the second half of the century: the full-length, full-face effigy, which under the *ancien régime* had been the sole prerogative of royalty, now spread to every social class. Hébert maintained this traditional pose in his portrait of Princess Clothilde of Savoy (1860, Musée national du château de Versailles); but the wives of bankers and artists, the women of the upper and lower bourgeoisie, and even farmers' wives, were now to be found monopolising great canvases over two metres high. There is often great dignity in their poses, as in Monet's *Madame Gaudibert* (1868, Musée d'Orsay, Paris), Carolus-Duran's *The Lady with a Glove* (1869, Musée d'Orsay, Paris), Bonnat's *Madame Cahen d'Anvers* (1891, Musée Bonnat, Bayonne) and Roll's *Manda Lamétrie, Farmer's Wife* (1887, Musée d'Orsay, Paris). Conversely, right at the beginning of the century, Prud'hon had shown Empress Josephine – and Gros had shown Lucien Bonaparte's wife, Christine Boyer – lost in a dream amid a mood-enhancing landscape, very much as women and not as princesses (both works, Musée du Louvre, Paris).

1

The half-length portrait was the most common. It owes its popularity to its ability to convey a certain degree of intimacy and naturalness, a directness of contact between painter and sitter, and between sitter and viewer. David's portraits, in their utter simplicity, often carry symbolic and quasi-heroic overtones, as in *Madame Trudaine* (1792) and *Madame de Verninac* (1799) (both Musée du Louvre, Paris), works that are a superb embodiment of their age. And as for Ingres: from the disconcerting *Madame Aymon* (1806, Musée des Beaux Arts, Rouen) to the absently opulent *Madame Moitessier* (1856, National Gallery, London), by way of the pensive, mysterious *Madame de Senonnes* (c.1816, Musée des Beaux Arts, Nantes) and the frail and troubled *Madame Marcotte de Sainte-Marie* (1826, Musée du Louvre, Paris), he gives us a delicate, complex and varied gallery of types drawn from the bourgeoisie which arose under the Empire, expanded under the Restoration and consolidated its position under the Second Empire. The Ingres formula was constantly revived in the work of his pupils and heirs, direct and indirect, until it finally succumbed to the cataclysms of the turn of the century. In the works of Chassériau, Amaury-Duval, Delaroche, Flandrin, Lehmann, Hébert, Bonnat and others beside, it is serene, subtle, hieratic and languid by turns.

The Realists and Impressionists often used a smaller format to convey a less contrived, more direct, more positive view of their sitters. Courbet's images make no concessions, as in *La mère Grégoire* (1855, Art Institute of Chicago), or *Madame Proudhon* (1865, Musée du Louvre, Paris). Manet, in his *Berthe Morisot* (1872, private collection), captures a fleeting glimpse of the sitter's alert and mobile features. Degas and Toulouse-Lautrec bring an element of cruelty, not unmixed with affection, to the unprepossessing features of, respectively, the *Duchess of Montejasi and her Daughters* (1876, private collection) and *Justine Dieuhle* (1891, Musée d'Orsay, Paris).

Among the countless portraits of the nineteenth century, there are some that seem to stand out as more than usually characteristic of their time. There were, for instance, an increasing number of portraits of women as creative artists: whether writers, such as George Sand (by Delacroix, 1838, Ordrupgaard Museum, Copenhagen) and Marie d'Agoult (by Lehmann, Musée Carnavalet, Paris), or painters, like Madame Haudebourg-Lescot (1825, Musée du Louvre, Paris) and Marie Bashkirtseff (1882, Musée du Petit Palais, Paris), or, above all, stage performers. The unprecedented importance of the theatre and the opera in the nineteenth century was reflected in the fame accorded to actresses and prima donnas, and in the numerous portraits that were painted of them. In the *Portrait of Pasta as a Muse* by Gérard, (1824, Musée Fabre, Montpellier), in *Rachel, or Tragedy* by Amaury-Duval (1854, illus. p.101), in Baudry's *Madeleine Brohan* (1860, Musée d'Orsay, Paris), and Bonnat's *Madame Pasca* (1874, Musée d'Orsay, Paris), and through to the sumptuous *Portrait of*

Sarah Bernhardt by Georges Clairin (1876, Musée du Petit Palais, Paris and c. 1886, Musée des Beaux Arts, Tourcoing), it is possible to trace the evolution of the theatrical portrait from an allegory to an increasingly spectacular genre scene.

The growing importance that was attached to the idea of the family as a closed group; the difficulty of finding sitters and commissions for a new artist without prior evidence of ability; the filial piety which was one of the nineteenth century's prime virtues: all these contributed to a tendency for artists to paint portraits of their mothers – who had, in so many cases, encouraged and supported their artistic vocations. These works are often something of a pictorial profession of faith; they also express an Oedipal feeling that is only now coming under scrutiny. These portraits share a consistent sense of restraint, a love of direct and unadorned reality. The mothers are modest *bourgeoises*, or peasant women in their Sunday best, their faces resigned and indulgent, deep in gentle reverie or absorbed in prayer: *Madame Chassériau* (1836, Musée du Louvre, Paris), *Madame Hébert* (1850, Musée Hébert, Paris), *Madame Delaunay* (1863, Musée d'Orsay, Paris; and 1869, Musée des Beaux-Arts, Nantes), *Madame Bonnat* (1893, Musée d'Orsay, Paris), *Madame Le Rolle* (1895, Musée d'Orsay, Paris), *Madame Blanche* (1890, Musée du Petit Palais, Paris), and a great many others.

Sisters and young wives are other sitters who serve to express closeness, loyalty, love, affection, and also the social position that the painter wishes to establish, together with his conception of the place occupied by women in his own life. These portraits – reserved, austere, coquettish, elegant, with their overtones of Parisian *bon ton* or provincial naïvety – vary widely in size, layout and tone. They encompass David's almost emblematic *Madame de Verninac* (1798, Musée du Louvre, Paris); Chassériau's *Mesdemoiselles C.*, reserved and mysterious (1843, Musée du Louvre, Paris); Millet's *Pauline Ono*, with her touching naivety (1843, Musée Thomas Henry, Cherbourg); Courbet's faintly perverse *Juliette Courbet* (1844, Musée du Petit Palais, Paris); Flandrin's gentle *Madame Flandrin* (1846, Musée du Louvre, Paris); and Degas's haughty *Thérèse Degas* (1863, Musée d'Orsay, Paris). They range from the naturalness of *Madame Manet at the Piano* (1868, Musée d'Orsay, Paris), to the monumentality of *Madame Cros* (1891, Musée d'Orsay, Paris).

Whether slight or ponderous, intimate or formal, these portraits of women convey the varied inner lives of their sitters: they are a view of the self and the soul, a revelation of character. They express individuality and inherent qualities, but also such factors as the social status of a husband, or the woman's own decrepitude.

The end of the nineteenth century marked a crisis, which called into question the whole art of portraiture. The formulas elaborated across the centuries now underwent a profound transformation, partly as a consequence of the rise of

photography, but also because the whole genre had been undermined by such artists as Cézanne, Gauguin and the Nabis. Cézanne's *Woman with a Coffee-Pot* (1890-4, Musée d'Orsay, Paris) is a serene, monumental, hieratic, almost abstract image in which all appeal to sensibility has been eradicated: the artist is concentrating exclusively on issues of material and form. In an entirely comparable way, the primitivism and syntheticism of Gauguin's *La belle Angèle* (1889, Musée d'Orsay, Paris) conveys the message that the psychological portrait is a thing of the past, and that the only issues that remain are those of pure painting.

Painters increasingly turned their attention to depicting women in a social context; the genre scene took on a depth of meaning, and an emotional intensity, that it had never possessed before.

Kinds of painting began to amalgamate: history painting drifted into anecdote, and genre scenes acquired an exemplary value which tended to transform them into archetypes. The life lived by women in contemporary society became one of the great nineteenth-century subjects, in painting as in literature. New types appeared: the maiden, pure and artless, clad in white; the wife as the symbol – the showcase – of her husband's wealth; the mother, nurturing and protecting her children; the grief-stricken widow in black; but also the mother oppressed by penury, or the fallen woman. The rise of Realism, as the century wore on, and the assertion of new ideologies, brought in their train the literary and pictorial embodiment of the Victorian family virtues, as contrasted with the world of the expensive prostitute, and of the virtues of the countryside, as compared with the perils and corruptions of the big city in which girls are seduced, abandoned and ruined: Fantine, in Victor Hugo's *Les Misérables*, is a classic case.

The birth of the idea of nationhood, and the development of the concept of *la Patrie*, were corollaries of the introduction of universal military service. They fostered the emergence of new subject areas: the grief of the war widow, the weeping sister, the fatherless daughter, were new themes, they were explored by Delacroix, in his romantic and sentimental *Orphan Girl*, set in a cemetery (1824, Musée du Louvre, Paris), and by Bouguereau in *All Souls' Day* (*Le Jour des Morts*, 1859, Musée des Beaux Arts, Bordeaux), a work of grave purity and restraint, and *Mail from Tonkin* (1885, Musée de Beaux Arts, Mulhouse), a grand anecdotal scene distinguished by an intense reserve.

The predilection for painting women from Brittany, from Alsace – symbol of suffering France – and from Provence is a symptom of the rise of interest in folklore, and of the growing awareness of the variety of the French regions. In their naïvety, their purity and their grandeur, these peasant women in costume provided a marked contrast with the frivolity, the slim figures and the flighty manners of the

metropolitan women who became a recognisable type in themselves, as in Renoir's *La Parisienne* (1874, National Museum of Wales, Cardiff) or the Parisiennes of Béraud (Musée Carnavalet, Paris) or Goeneutte.

The theme of the 'Orient', and the erotic fantasies that went with it, was reinforced by, among other things, the wars of colonisation which took conscripts overseas. From Delacroix's *Women of Algiers in their Apartment* (1834, Musée du Louvre, Paris and 1839, Musée Fabre, Montpellier) to Lecomte de Noüy's *White Slave*, (1888, Musée des Beaux Arts, Nantes), the theme gradually emerged from its dreamy remoteness to become a known reality, while retaining just enough of its unfathomed mystery for fantasies to feed on: the largest brothel in Paris at that time was called the Maison Orientale.

Realist painters often showed women as social victims. Frequently, they were the victims of grinding poverty, in the cities and above all in the countryside, as in Danloux's *Scene of Poverty*, (c.1803, Musée du Louvre, Paris), Antigna's *The Poor Woman* (1857, Musée des Beaux Arts, Orléans) and even Millet's *Winter* (1874, National Museum of Wales, Cardiff), in which the artist takes everyday life as his point of departure for a silent, mystic, timeless allegory. Women might also be victims sacrificed in the cause of male pleasure, as in such works by Courbet as *Sleepers* (1866, Musée du Petit Palais, Paris); or they might be social outcasts, as in Manet's *The Barmaid at the Folies-Bergère* (1869, Courtauld Institute Galleries, London) or Degas's *Absinthe* (1876, Musée d'Orsay, Paris). There is a world of difference between these women – the objects of compassion or of pity, of tender concern or of vicarious indignation – and the woman who is seen being carried off by pirates in a painting by Luminais: this is no more than a dream of a lovely lady seized by savages, an image with an erotic charge that recalls Hollywood (illus.p.74).

Genre scenes now ceased to be intended merely as entertainment: they aimed to make people think. Everyday life came to be infused with the heroic, and the hierarchy of genres went by the board.

The Revolution saw Woman as a wife, a mother and a patriot; Romanticism made her a sentimentalised victim or a redeemer; Realism saw her as the glorified or sacrificial symbol of the new society; the academics, the Pompiers, saw her as an embodiment of their own fantasies; and the Symbolists made her a *belle dame sans merci*.

There are numerous victim-figures in the literature, painting and sculpture of the nineteenth century; many of them aspire to be the salvation of Man, as with Brünnhilde, the grandest victim of them all, who sets fire to the world and saves it. There are countless embodiments of yearnings and dreams, from Ingres to Bouguereau, from Delacroix to Gustave Moreau. So many figures, so many

metamorphoses in the course of one century; what a distance separates the virtuous women who weep in David's *Brutus* from the *Demoiselles d'Avignon* of Picasso! The history of the age can be traced through this succession of female figures: aristocrats, *bourgeoises* and paupers; paragons of virtue and objects of desire; dreaming or dreamt-of, passionate or frigid, they are emblems of the evolution of a society, its upheavals and its aesthetic values.

Translated from the French by David Britt

Author's acknowledgments

Georges Brunel, Thérèse Burollet, Claude Cosneau, Ariel Denis, Jacques Foucart, Christian Heck, Jean Lacambre, Sylvie Lecoq, Corinne Le Solliec, Caroline Mathieu, Eric Moinet, Béatrice Sarrazin and Noëlle-Claire Vuarnet

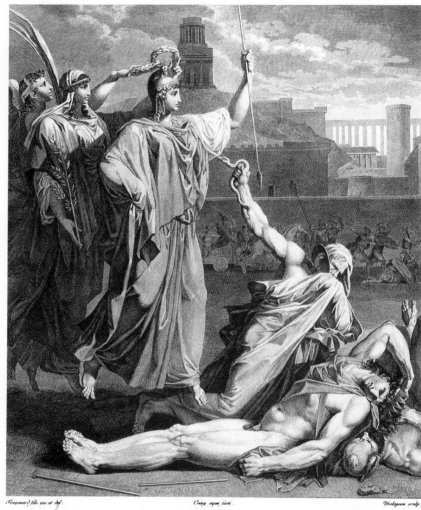

A-E Fragonard
Frontispiece to 'Tableaux de la Révolution Française', 1815
British Museum, London

TABLEAUX DE LA REVOLUTION FRANÇAISE.

Sad were the days, now happily no more,
When raging parties France in fetters bound;
Her cities waste, and drench'd her fields with gore,
While virtue wept, and no asylum found.
Valour and genius hail! that peace proclaim,
Drown'd is the voice of faction in these lands,
Honour great Gallia to thy warlike bands,
And let their trophies tell thy lasting fame!

By P.A. Miger

Auguste Flandrin
The Woman in Green,
1835
Musée des Beaux
Arts, Lyon

L-L Boilly
A Girl at a Window,
c.1799
National Gallery,
London

Pierre Narcisse Baron
Guérin
Clytemnestra, 1816
Musée des Beaux
Arts, Orléans

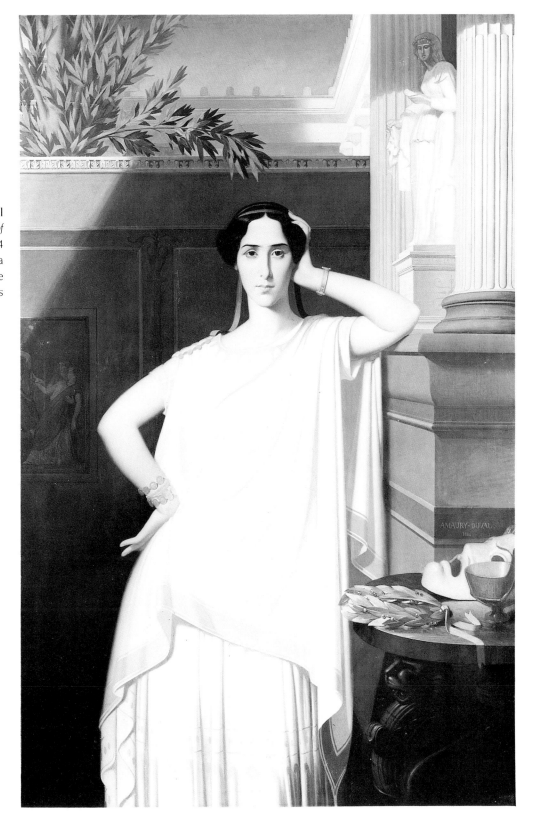

Amaury-Duval
Tragedy (Portrait of Rachel), 1854
Bibliothèque de la
Musée de la Comédie
Française, Paris

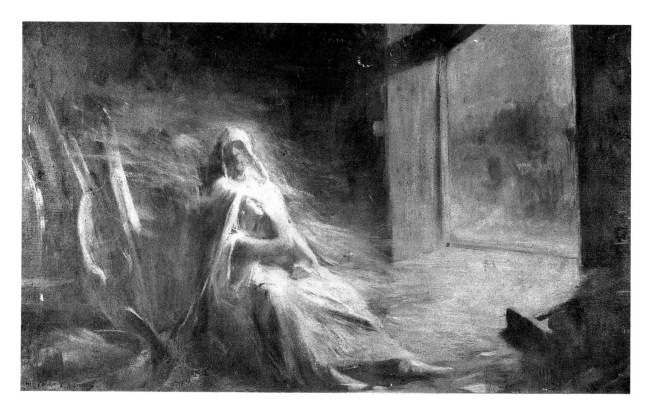

L-A Girardot
Ruth and Boaz, 1887
Musée des Beaux Arts, Troyes

Ruth, the Moabite, was a virtuous woman
who sustained her mother-in-law, Naomi,
in hard times: '. . . whither thou goest, I
will go.' (Ruth, I, 16). Widowed, she
married Boaz, an elder and 'mighty man of
wealth'. She epitomised duty and
continuity with regard to the family and
society.

T Chassériau
Mary Queen of Scots and
Rizzio, c.1845
Musée des Beaux
Arts, La Rochelle

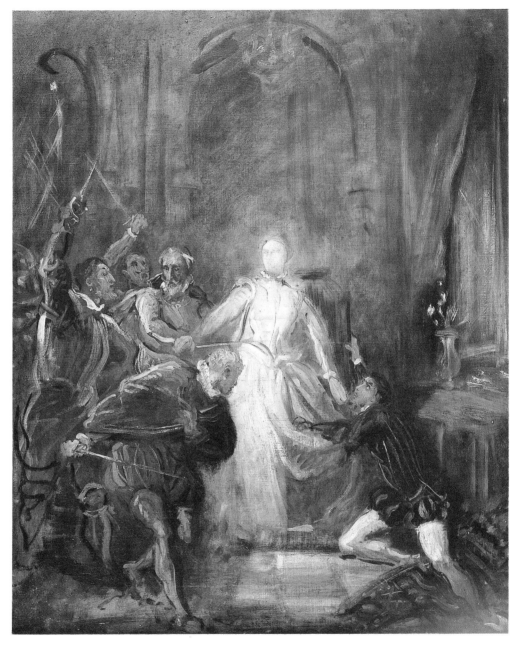

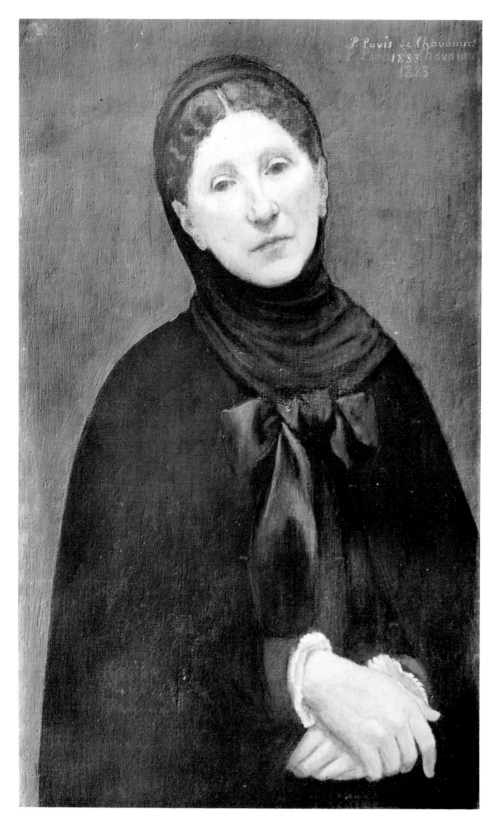

P Puvis de Chavannes
Portrait of Mme Puvis de Chavannes, 1883
Musée des Beaux Arts, Lyon

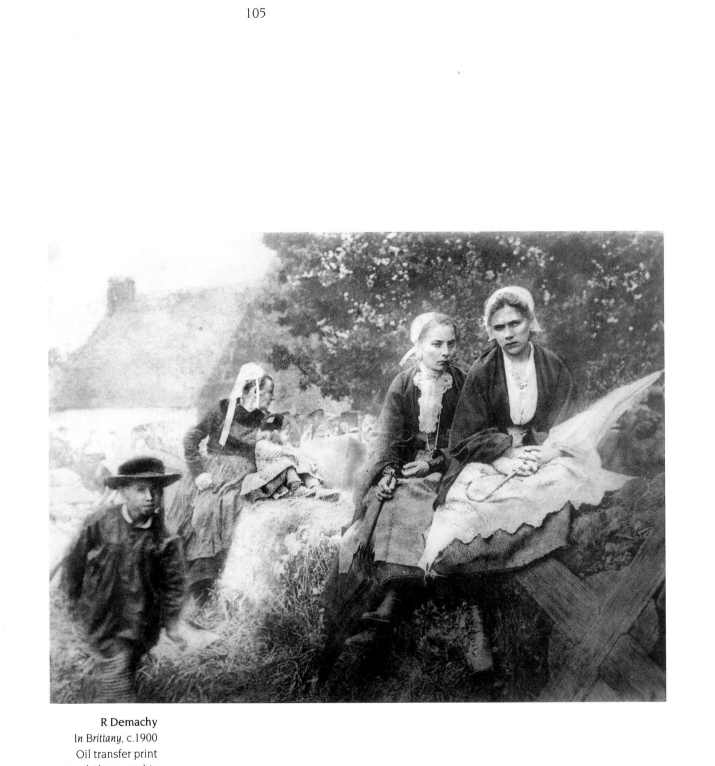

R Demachy
In Brittany, c.1900
Oil transfer print
Royal Photographic
Society

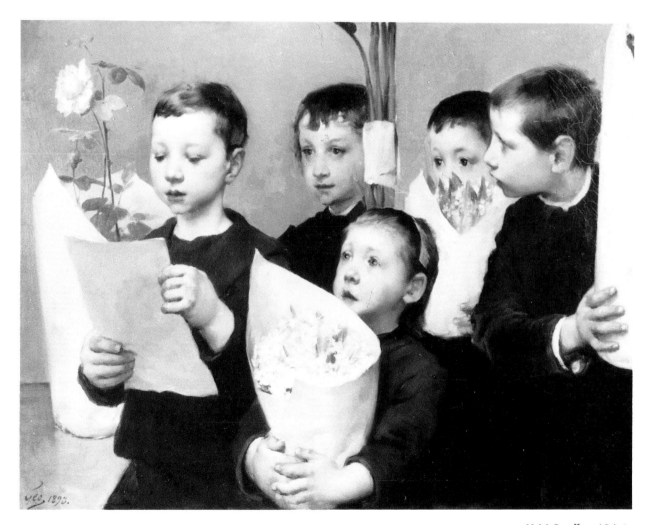

H-J-J Geoffroy (Géo)
An Anniversary Bouquet,
1892
Musée des Beaux
Arts, Saintes

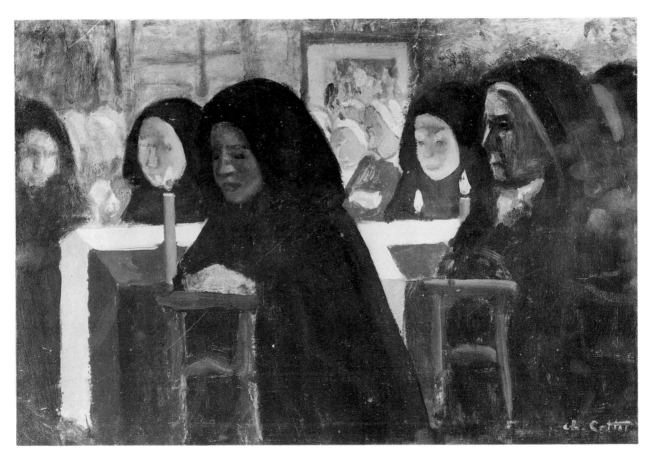

C Cottet
Breton Funeral, c.1893
Musée des Beaux
Arts, Brest

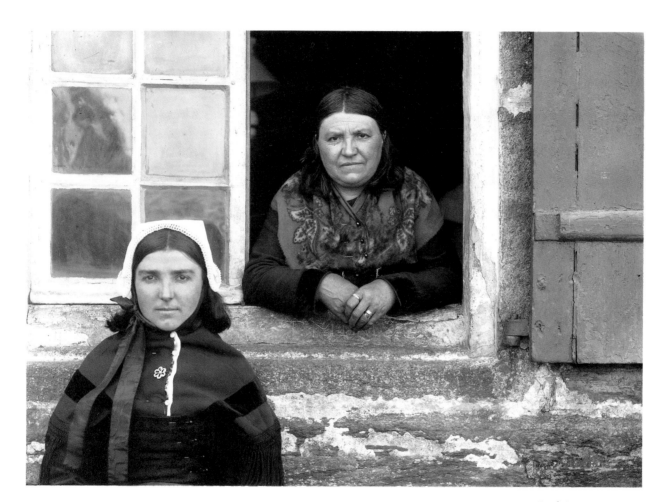

Paul Gruyer
Women of Ouéssant,
c.1900
Musée de Bretagne,
Rennes

E Bernard
Study of Breton Women,
c.1888
Musée des Beaux
Arts, Quimper

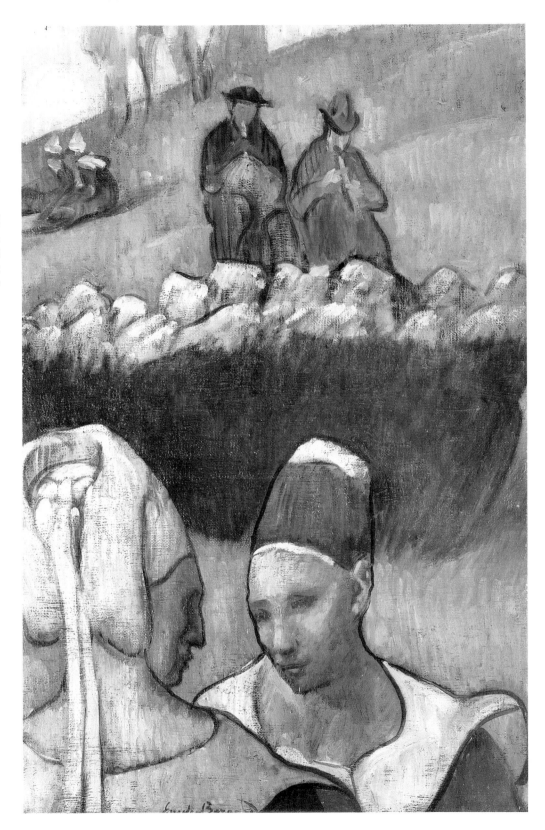

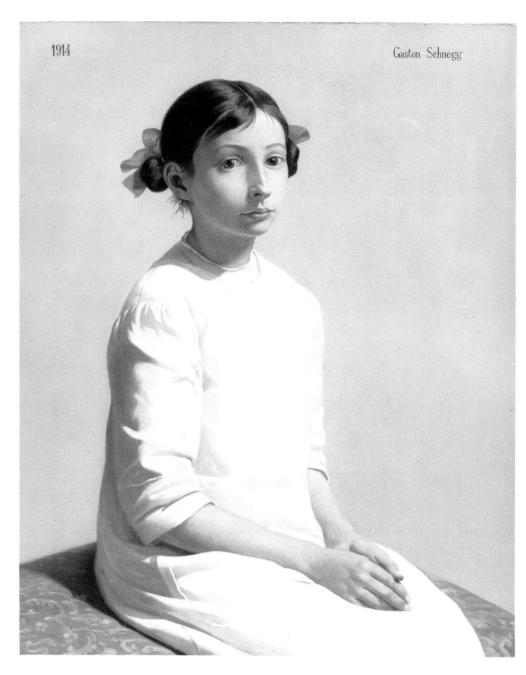

1914

Gaston Schnegg

G Schnegg
Portrait of Jeanne in a
White Dress, 1914
Musée des Beaux
Arts, Bordeaux

C Despiau
Young Girl of the Landes,
1909
Musée de
Boulogne-Billancourt,
Paris

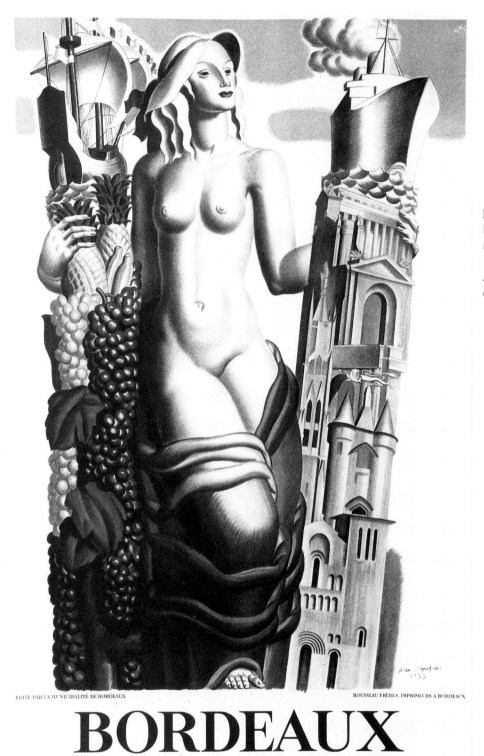

EDITÉ PAR LA MUNICIPALITÉ DE BORDEAUX

ROUSSEAU FRÈRES, IMPRIMEURS A BORDEAUX

BORDEAUX
SON PORT · SES MONUMENTS · SES VINS

J T Dupas
Bordeaux, son port, ses monuments, ses vins,
1937
Archives Municipales
de Bordeaux

Aristide Maillol
Draped Torso, c.1911
Musée des Beaux
Arts, Dijon

T de Lempicka
Young Girl in Green,
c.1927
Musée National d'Art
Moderne, Centre
Georges Pompidou

J Despujols
La Pensée, c.1928
Musée National d'Art
Moderne, Centre
Georges Pompidou

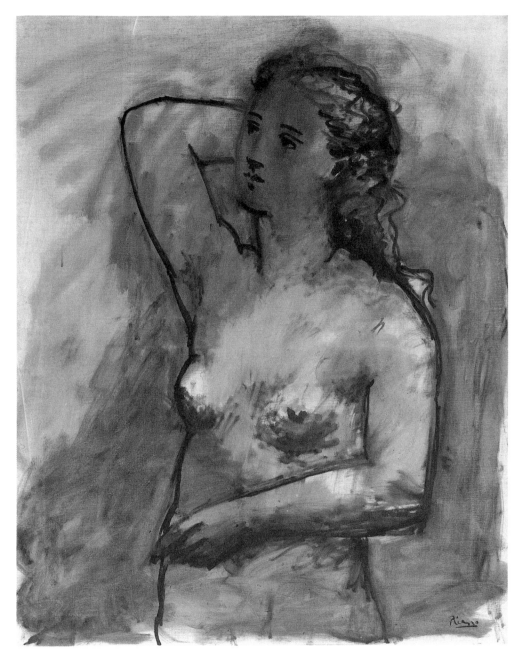

P Picasso
Nu à mi-corps, 1923
Musée National d'Art
Moderne, Centre
Georges Pompidou

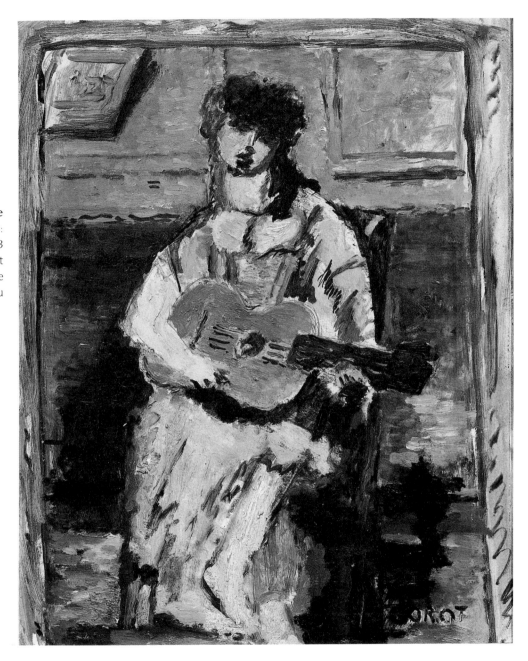

G Braque
Woman with Mandoline:
after Corot, 1923
Musée National d'Art
Moderne, Centre
Georges Pompidou

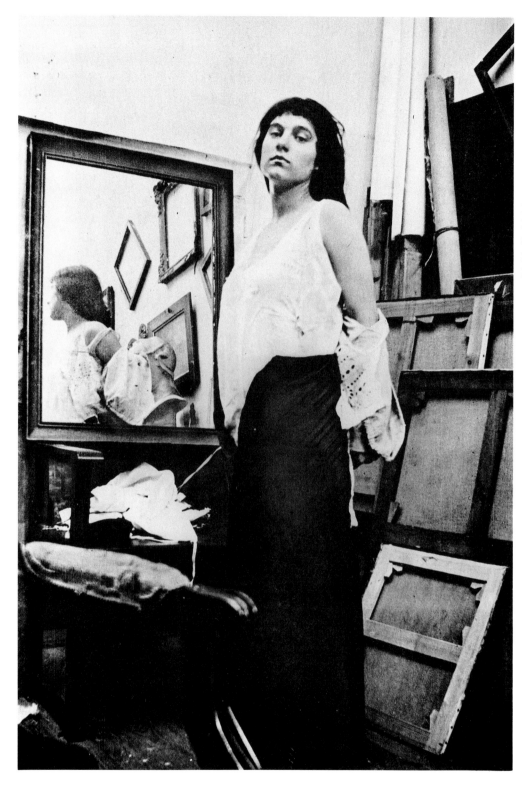

P Bonnard
Model in the Artist's Studio, c.1916
Photograph
Musée d'Orsay

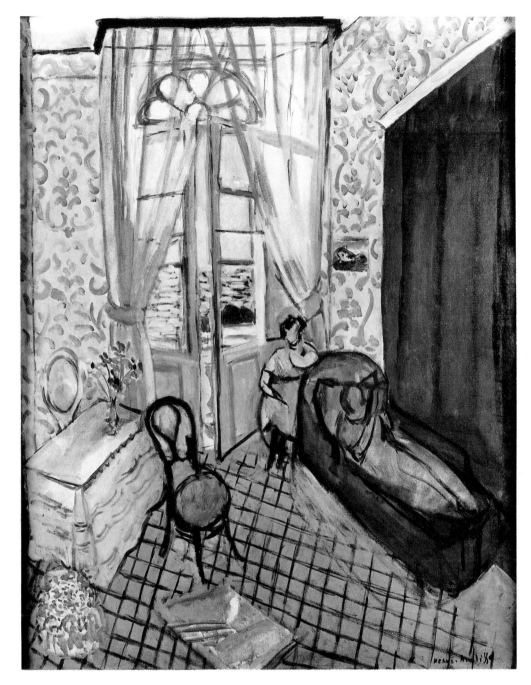

H Matisse
The Divan, 1921
Musée de l'Orangerie,
Collection Walter
Guillaume

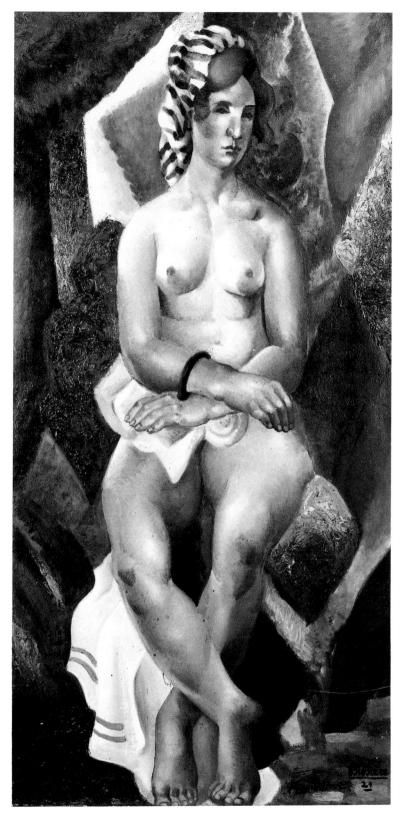

R Bissière
Nude, 1921
Musée de Peinture et
de Sculpture,
Grenoble

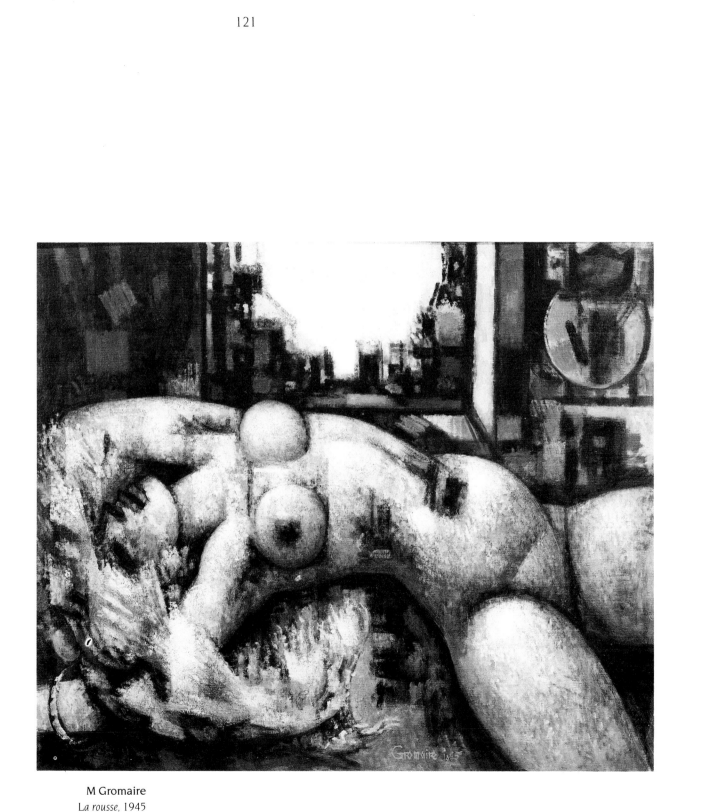

M Gromaire
La rousse, 1945
Musée National d'Art
Moderne, Centre
Georges Pompidou

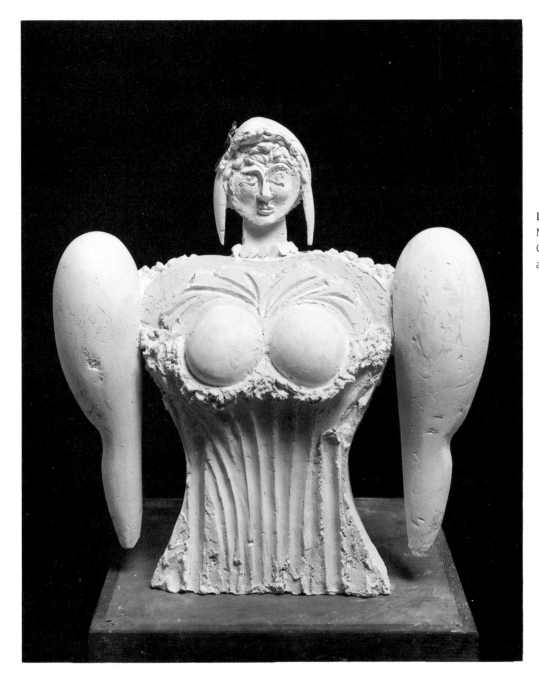

Louis Cane (b.1943)
Marianne, 1986
Collection of the
artist

V Brauner
Tot-in-tot, 1945
Musée National d'Art
Moderne, Centre
Georges Pompidou

A Marquet
Nude, or Woman on a Divan, 1912
Musée National d'Art Moderne, Centre Georges Pompidou

E Boubat
Lella, Brittany, 1947
Musée National d'Art
Moderne, Centre
Georges Pompidou

J E Laboureur
*An outdoor scene with a
poetry reader and a nude
woman,* 1914
British Museum,
London

128

Balthus
La Toilette de Cathy,
1933
Musée National d'Art
Moderne, Centre
Georges Pompidou

List of works

Catalogue note
Entries are in alphabetical order by artist.
Sizes are given in centimetres, height first.
Works marked with an asterisk are shown at the Hayward Gallery only.
The following works are not exhibited: 27 53 54 104 142.

1 Louis Emile Adan (1839-1937)
The Ferryman's Daughter, 1884
Photogravure by Goupil, 36 x 51.5
The Trustees of the British Museum,
London

2 Guillaume Allabré (1746-1807)
Notre Dame de Chartres priez pour nous
(Our Lady of Chartres, pray for us)
Wood engraving with stencilled
colouring, 51.1 x 41.5
Musée National des Arts et
Traditions Populaires, Paris

3 Louis Allabré and Thomas Blin
*Ste. Clotilde reine de France priez
pour nous*
(St. Clotilde, Queen of France, pray for us)
Wood engraving with stencilled
colouring, 86 x 66.5
Musée National des Arts et
Traditions Populaires, Paris
Illus. p. 36

**4 Amaury-Duval (Amaury Eugène
Emmanuel Pineu-Duval) (1808-85)**
Tragedy (Portrait of Rachel), 1854
Oil on canvas, 67 x 115
Bibliothèque du Musée de la
Comédie Française, Paris
Illus. p. 101

**5 Jean Pierre Alexandre Antigna
(1817-78)**
Affliction, 1869
'*Esprit retourne à Dieu qui l'avait donné*',
Ecclesiastes XII.7., '*Le Seigneur m'a
tout ôté que le nom du Seigneur soit beni*',
Job I.21 ('. . . *and the spirit shall return
unto God who gave it.*' Ecclesiastes,
XII.7., '. . . *The Lord hath taken away;
blessed be the name of the Lord.*' Job I.21)
Engraving by F A Ledoux, printed
and published by Goupil, 77.3 x 58.5
The Trustees of the British Museum,
London

6 Balthus (b. 1910)
La Toilette de Cathy, 1933
Oil on canvas, 165 x 150
Musée National d'Art Moderne,
Centre Georges Pompidou, Paris
Illus. p. 128

**7 Charles Edouard de Beaumont
(1812-88)**
'*Suis-je à votre gout comme ça, polisson?*',
('*Is this more to your liking, you rascal?*')
Lithograph from *Le Charivari*, c.1850
19.5 x 16.7
The Board of Trustees of the Victoria
and Albert Museum, London

8 Charles Edouard de Beaumont
'*Veux-tu que je loue une loge pour l'opéra
comique?. . .*'
'*Non. . . je ne veux pas que tu fasses de
dépenses pour moi. . . nous irons tout
simplement au bal de l'opéra. . . de la tu me
mèneras souper à la maison d'or. . .*'
('*Do you want me to take a box for the
comic opera?. . .*'
'*No. . . don't go to any expense on my
behalf. . . we'll just go to the ball at the
opera. . . and then on to eat at the maison
d'or. . .*')
Lithograph published in *Le Charivari*,
1858-61, from 'Dialogues Parisiens'
(2nd series), 28.3 x 35.1
The Board of Trustees of the Victoria
and Albert Museum, London

9 Charles Edouard de Beaumont
'*Ça ne te fait rien que ta femme ait des
amants?*'
'*Si – ça me fait une societé*'
('*Doesn't it matter to you that your wife has
lovers?*'
'*Oh yes. . . it makes me a member of the
club*')
Pencil and gouache on paper,
26 x 19
Private collection, Paris

10 Georges Becker (1845-1900)
Respha protège les corps de ses fils contre les oiseaux de proie.
Respha protecting the bodies of her sons against birds of prey.
Photogravure by Goupil, from the Salon of 1875, Pl.IV, 55.5 x 35.7
The Trustees of the British Museum, London

11 Pierre de Belay (1890-1947)
La Bretonne, 1940
Oil on canvas, 73 x 63
Musée des Beaux Arts, Quimper

12 Emile Bernard (1868-1941)
Study of Breton Women, c.1888*
Oil on canvas, 81 x 54
Musée des Beaux Arts, Quimper
Illus. p. 109

13 Raphael Binet (1880-1961)
Woman in Giz Fouen costume, 1922-3
Contemporary print from an original negative
Musée de Bretagne, Rennes

14 Roger Bissière (1888-1964)
Nude, 1921
Oil on canvas, 146 x 75
Musée de Peinture et de Sculpture, Grenoble
Illus. p. 120

15 Louis-Leopold Boilly (1761-1845)
A Girl at a Window, c.1799
Oil on canvas, 55 x 45
The Trustees, The National Gallery, London
Illus. p. 99

16 Pierre Bonnard (1867-1947)
Model in the Studio of the Artist, c.1916
Contemporary print from an original negative
Musée d'Orsay, Paris
Illus. p. 118

17 Pierre Bonnard
Marthe bathing, c.1908
Contemporary print from an original negative
Musée d'Orsay, Paris

18 Pierre Bonnard
Grandmother and Child, 1894
Oil on panel, 34.3 x 42
Leeds City Art Gallery

19 Pierre Bonnard
Edwards and Misia Sert on a yacht, c.1906
Oil on canvas, 37.4 x 45.9
Musée de la Ville de Poitiers et de la Societé des Antiquaires de l'Ouest

20 Edouard Boubat (b.1923)
Lella, Brittany, 1947
Silver print, 39.4 x 29.1
Musée National d'Art Moderne, Centre Georges Pompidou, Paris, on loan from the FNAC
Illus. p. 125

21 Henri Louis Bouchard (1875-1960)
Tête de Victoire, 1926
Bronze, 52 x 20 x 37
Musée Henri Bouchard, Paris
Illus. p. 35

22 Pierre Boucher (b. 1908)
Paris délivré par son peuple, September 1944
Cover of pamphlet containing photographs by Robert Doisneau and René Zuber, 31 x 24
Private collection
Illus. p. 62

23 Emile-Antoine Bourdelle (1861-1929)
La France, 1923
Bronze, h.134
Musée Bourdelle, Paris
Illus. p. 65

24 Georges Braque (1882-1963)
Woman with Mandoline: after Corot, 1923
Oil on card, 41 x 33
Musée National d'Art Moderne, Centre Georges Pompidou, Paris
Illus. p. 117

25 Brassai (Gyula Halasz) (1894-1985)
Toilette dans une maison de passe, c.1932
Silver print, 35 x 27.5
Musée National d'Art Moderne, Centre Georges Pompidou, Paris

26 Brassai (Gyula Halasz)
Chez Suzy, Introductions, c.1932
Silver print, 30.9 x 22.5
Musée National d'Art Moderne, Centre Georges Pompidou, Paris, on loan from the FNAC

27 Brassai (Gyula Halasz)
Chez Suzy, c.1932
Silver print, 29.8 x 22.5
Collection Madame Brassai

28 Victor Brauner (1903-66)
Tot-in-tot, 1945
Bronze, 37.7 x 29.5 x 9.1
Musée National d'Art Moderne, Centre Georges Pompidou, Paris
Illus. p. 123

29 Victor Brauner
Maternité, 1955
Oil on canvas, 92 x 73
Musée de Peinture et de Sculpture, Grenoble

30 Jules Adolphe Aimé Breton (1827-1906)
The Potato Harvest, 1873
Photogravure by Goupil after a painting
The Trustees of the British Museum, London

31 Jules Adolphe Aimé Breton
The Wood Gatherer, 1883
Oil on canvas, 107 x 74
Musée d'Arras

32 Louis Cane (b.1943)
Marianne, 1986
Bronze, 50 x 48 x 15
Lent by the artist
Illus. p. 122

33 Leonetto Cappiello (1875-1942)
L'Oeuvre, 1933*
Design for a poster
Gouache, 135 x 196
Musée des Beaux Arts, Lyon

34 Armand Charles Caraffe (1762-1822)
*Le destin règle le cours de la vie et de vains
songes en font le charme.*
*(Destiny rules the course of life and vain
dreams provide the charm.)*
Colour engraving by Lefèvre-
Marchand, published by Osterwald
l'Aîné, Paris, 1802
46 x 54.2
The Trustees of the British Museum,
London
Illus. p. 16

35 Jean-Baptiste Carpeaux (1827-75)
La Palombelle, 1856
(subject's real name: Barbara
Pasquarelli, born in the village of
Palombarra on the hills above
Rome)
Terracotta, 40.2 x 26 x 28.1
Musée d'Orsay, Paris

36 Henri Cartier-Bresson (b.1908)
Italy, 1933
Silver print, 40 x 30
Collection of the artist

37 Auguste Elisée Chabaud
(1882-1955)
Yvette, 1907*
Oil on board, 53.5 x 37
Musée d'Art Moderne, Troyes

38 Cham (Amédée Charles Henri,
Comte de Noë) (1818-79)
*La Victoire, 'Je vous trouve bon. . . mon
brave general Giulay!. . . vous parlez de
moi dans toutes vos proclamations. . . mais
je ne vous connais pas, mon cher. . . vous et
moi n'avons jamais été ensemble!. . .)*
*(Victory, 'You're a sound chap . . . General
Giulay! . . . you're good enough to mention
me in all your announcements. . . but I
don't know you, old boy. . . we've never had
much to do with each other!. . .')*
Lithograph from *Actualitées*
The Board of Trustees of the Victoria
and Albert Museum, London

39 Théodore Chassériau (1819-56)
Mary Queen of Scots and Rizzio, c.1845
Oil on canvas, 61 x 48
Musée des Beaux Arts, La Rochelle
Illus. p. 103

40 Robert Combas (b.1957)
Portrait of Ketty as a Cat, 1981
Acrylic on canvas, 110 x 104
Collection D.M., Paris

41 Jean Baptiste Corot (1796-1875)
Girl reading, with Flowers in her Hair,
1845
Oil on canvas, 47 x 34
Musée du Louvre, Paris

42 Charles Cottet (1863-1925)
Head of Breton Woman, 1909
Oil on board, 61 x 47
Musée des Beaux Arts, Nantes

43 Charles Cottet
Breton Funeral, c.1893
Oil on paper on card, 35.3 x 53.3
Musée des Beaux Arts, Brest
Illus. p. 107

44 Thomas Couture (1815-79)
A Vow to the Madonna, 1856
Oil on canvas, 190 x 130
Musée départemental de l'Oise,
Beauvais
Illus. p. 86

45 Honoré Daumier (1808-79)
The Burden, c.1860
Oil on panel, 39.3 x 31.1
The Burrell Collection, Glasgow
Museums and Art Galleries
Illus. p. 44

46 Honoré Daumier
The Side-show, c.1865
Black chalk, pencil, pen and wash,
40.6 x 29.5
The Burrell Collection, Glasgow
Museums and Art Galleries
Illus. p. 66

47 School of David
Rose Ducreux, 1795
Oil on canvas, 172 x 128
Musée des Beaux Arts et
d'Archéologie, Rouen

48 David d'Angers (Pierre-Jean David)
(1788-1856)
Liberté, 1839
Bronze, 58.5
Musée du Louvre, Paris

49 Eugène Delacroix (1798-1863)
African Pirates seizing a Young Woman,
1852
Oil on canvas, 65 x 81
Musée du Louvre, Paris

50 Robert Demachy (1859-1936)
In Brittany, c.1900
Oil transfer print, 27 x 20
The Royal Photographic Society,
Bath
Illus. p. 105

51 Robert Demachy
In the Greenery, c.1900
Oil transfer print, 17.5 x 11
The Royal Photographic Society,
Bath

52 Maurice Denis (1870-1943)
The Shop, 1917
Oil on canvas, 51 x 51
Musée des Beaux Arts, La Rochelle

53 Maurice Denis
Classic French Culture, 1937
Oil on card, 30 x 62
Musée départemental du Prieuré,
St. Germain-en-Laye

54 Maurice Denis
Lisbeth reading on the balcony at Silencio,
1921
Oil on canvas, 43 x 64
Musée départemental du Prieuré,
St. Germain-en-Laye

55 André Derain (1880-1954)
La Parisienne, 1928
Oil on canvas, 81 x 65.5
Musée National d'Art Moderne,
Centre Georges Pompidou, Paris, gift
of Mme Geneviève Gallibert

56 André Derain
Alice Derain, undated
Sheet metal, 26.5 x 21 x 6
Musée National d'Art Moderne,
Centre Georges Pompidou, Paris

57 Charles Albert Despiau (1874-1946)
Young Girl of the Landes, 1909
Bronze, 44.8 x 27 x 17
Musée de Boulogne-Billancourt,
Paris
Illus. p. 111

58 Jean Despujols (1886-1965)
La Pensée, c.1928
Oil on canvas, 100 x 81
Musée National d'Art Moderne,
Centre Georges Pompidou, Paris
Illus. p. 115

59 Robert Doisneau (b.1912)
Concierge with spectacles, rue Jacob, 1945
Silver print, 40 x 30
Collection of the artist
Illus. p. 64

60 Robert Doisneau
Creatures of Dreams, 1952
Silver print, 40 x 30
Collection of the artist

61 Robert Doisneau
The Wedding Ribbon, 1951
Silver print, 40 x 30
Collection of the artist
Illus. p. 127

62 Robert Doisneau
*Mlle Anita, at the dance-hall 'La Boule
Rouge', rue de Lappe, 11th Arr., Paris,*
1951
Contemporary print from an original
negative
Musée National d'Art Moderne,
Centre Georges Pompidou, Paris

63 Gustave Doré (1833-83)
An Incident in the Siege of Paris in 1870,
97 x 130
Musée des Beaux Arts André
Malraux, Le Havre

64 Gustave Doré
Sisters of Charity saving a Child,
1870-71
Oil on canvas, 97 x 130
Musée des Beaux Arts André
Malraux, Le Havre

65 Jean Théodore Dupas (1882-1964)
*Bordeaux, son port, ses monuments, ses
vins,* 1937
Lithographed poster, by Imprimerie
Rousseau Frères, Bordeaux,
100 x 61.7,
Archives Municipales de Bordeaux
Illus. p. 112

**66 Théodore Fantin-Latour
(1836-1904)**
Mlle Charlotte Dubourg, 1882
Oil on canvas, 117 x 92
Musée d'Orsay, Paris

67 Auguste René Flandrin (1804-43)
*Portrait of a Woman, called The Woman in
Green,* 1835*
Oil on canvas, 46 x 35
Musée des Beaux Arts, Lyon, gift of
Mme Lefèbre, 1918
Illus. p. 98

68 Jean-Louis Forain (1852-1931)
*La traite des Blanches, '. . . Et elle parle très
bien l'anglais',* c.1895
(*White slave trade, '. . . and she speaks good
English, too'*)
Colour process engraving, 32 x 24.5
Private collection

69 Tsugouharu Foujita (1886-1968)
Two Nudes, 1929
Watercolour and ink, 178 x 94
Musée National d'Art Moderne,
Centre Georges Pompidou, Paris

**70 Alexandre-Evariste Fragonard
(1780-1850)**
Frontispiece to *Tableaux de la
Révolution Française,* 1815
Lithograph by Malapaux, 48.5 x 31
The Trustees of the British Museum,
London
Illus. p. 97

71 Emile Fréchon (active 1890-1910)
Needlework, c.1900
Original print on printing-out paper,
23 x 29
The Royal Photographic Society,
Bath
Illus. p. 38

72 Emile Fréchon
Narration, c.1900
Original print on printing-out paper,
23 x 29
The Royal Photographic Society,
Bath

73 Emile Fréchon
Women reading, c.1900
Original print on printing-out paper,
23 x 29
The Royal Photographic Society,
Bath
Illus. p. 57

74 Démétrius Emmanuel Galanis
(1882-1966)
'. . . Et votre mari ne vous a jamais pincée
. . . avec un amant?'
'Jamais. . . Quand il commence à en
soupçonner un, il y a déjà
longtemps que j'en ai pris un autre!'
c.1900
('. . . And your husband has never found
you out. . . with a lover?'
'Never. . . by the time he's begun to suspect
one, I've already moved on to another!')
From Le Rire
Colour process engraving,
53.3 x 37.9
The Board of Trustees of the Victoria
and Albert Museum, London

75 Pablo Gargallo (1881-1934)
Kiki de Montparnasse, 1928
Bronze, 20.5 x 16
Musée d'Art Moderne de la Ville de
Paris, Paris

76 Paul Gavarni (Hippolyte-Sulpice-
Guillaume Chevalier) (1804-66)
'Avoir perdu ses plus belles années, tout çe
qu'on avait d'illusion, de simplicité de
coeur, beauté. . . jeunesse!. . . avenir. . . et
tout! . . . – Pour un crapaud comme ça!'
('To have thrown away the best years of her
life, all her hopes, her innocence, beauty. . .
youth!. . future. . . everything! – For a
toad like that!')
From Le Charivari, 24 December 1841,
as one of the series 'Les Lorettes',
Lithograph, 26.8 x 19
The Board of Trustees of the Victoria
and Albert Museum, London

77 Paul Gavarni
La Fée: (Tout haut) 'Allez jeunes amants
ne cessez pas d'être vertueux et la fée
brillante veillera sur vous.'
(Tout bas) 'Hue'
(The Fairy Queen: 'Remember you young
lovers to keep to the paths of righteousness
and the good fairy will keep watch over you.'
(Sotto voce) 'Hmmm')
Plate 2 of set of 31 lithographs
entitled 'Les Coulisses', published in Le
Charivari, 1837-43
Lithograph, coloured by hand,
19.7 x 15.6
The Board of Trustees of the Victoria
and Albert Museum, London
Illus. p. 48

78 Paul Gavarni
'Mon homme!. . . un chien fini, mais le roi
des hommes,'
('My man!. . . a dead dog, but a king
among men')
From Le Charivari, 13 December 1846,
from the series (2nd series)
'Impressions de Ménage'., no.16,
Lithograph, printed by Aubert,
19.3 x 16.5
The Board of Trustees of the Victoria
and Albert Museum, London

79 Paul Gavarni
'Sac à papier! Dorothée. . . j'ai oublié le
mou de ton chat. . .'
'C'est ca! mais vous n'avez pas oublié le
biscuit pour votre oiseau, égoiste!. . . C'est
bon! C'est bon! Si mon chat n'a rien, je lui
donnerai l'oiseau, moi!'
('Goodness gracious! Dorothy. . . I forgot
your cat's meat. . .' 'That's just it! but I bet
you didn't forget cake for your bird. Always
thinking of yourself!. . . Alright! If my cat
has nothing to eat I'll see that it has the
bird!')
From Le Charivari, c.1846,
Lithograph, coloured by hand,
20.6 x 15.4
The Board of Trustees of the Victoria
and Albert Museum, London

80 Paul Gavarni
'Mon adoré, dis-moi ton petit nom'
('My dearest, tell me your name')
From the series 'Les Lorettes',
1841- 1843
Pencil on paper, 17 x 21
Private collection, Paris

81 Paul Gavarni
'Ah qui m'embête! Ah qui m'embête,'
('Oh, so boring! Oh, so boring!')
Pencil, wash and gouache on paper,
18 x 12
Private collection, Paris

82 Géo (Henri-Jules-Jean Geoffroy)
(1853-1924)
An Anniversary Bouquet, 1892
Oil on canvas, 61 x 81
Musée des Beaux Arts, Saintes,
Illus. p. 106

83 Jean-Léon Gérôme (1824-1904)
Bellone, 1892
Patinated and gilded bronze,
polychrome terracotta, glass, with a
plaque by Lalique, 87 x 47 x 33
Musée Georges Garrett, Vesoul

84 Jean-Léon Gérôme
Truth emerging from a Well, 1896
Oil on canvas, 91 x 72
Musée d'Art et d'Archéologie,
Moulins

85 Louis-Auguste Girardot (1858-1933)
Ruth and Boaz, 1887
Oil on canvas, 38 x 64.5
Musée des Beaux Arts, Troyes
Illus. p. 102

86 Girodet (Anne-Louis Girodet de
Roucy-Trioson) (1767-1824)
Deluge, 1825
Lithograph by Aubrey Lecomte after
a painting of 1806, 81 x 60
Printed and published by Françisque
Noel
The Trustees of the British Museum,
London
Illus. p. 40

87 Adrienne Marie-Louise Grand
Pierre-Deverzy (1798-1869)
The Studio of Abel de Pujol, 1836
Oil on canvas, 98 x 135
Musée des Beaux Arts, Valenciennes

88 Marcel Gromaire (1892-1971)
La rousse, 1945
Oil on canvas, 80 x 100
Musée National d'Art Moderne,
Centre Georges Pompidou, Paris
Illus. p. 121

89 Paul Gruyer (1868-1930)
Women of Ouéssant, c.1900
Contemporary print from an original
negative
Musée de Bretagne, Rennes
Illus. p. 108

90 Pierre Narcisse Baron Guérin
(1774-1833)
Clytemnestra, 1816
Oil on canvas, 37 x 33
Musée des Beaux Arts, Orléans
Illus. p. 100

91 Pierre Narcisse Baron Guérin
Dido and Aeneas, 1816
Oil on canvas, 35 x 47
Musée du Louvre, Paris

92 Albert Guillaume (1873-1942)
*'Pourquoi maman ne veut-elle pas que je
regarde ça quand je suis avec elle?'
'Madame a p't'et' bien peur que
mademoiselle ait d'la désillusion quand
mademoiselle mariera.'*
('Why doesn't Mama want me to look at
that when I'm with her?'
'Madame is probably worried that miss
might be disillusioned when miss marries.')
From *Le Rire*, 1900-1905,
Process engraving, 20.6 x 11.8
The Board of Trustees of the Victoria
and Albert Museum, London

93 L. Haye (active late 19th century)
*'Agathe, joue-nous ton morceau a quatre
mains. . .'*
('Agatha, play us your piece for four
hands. . .')
Colour process engraving for
unidentified periodical, 26 x 20.6
The Board of Trustees of the Victoria
and Albert Museum, London

94 Jean Hélion (1904-87)
Nude and Flower Pots, 1947
Oil on canvas, 65 x 50
Musée National d'Art Moderne,
Centre Georges Pompidou, Paris
Illus. p. 68

95 Charles Huard (1874-1965)
*Rue des Nations, les visiteurs
du dimanche*, p.3
Toute la Province à Paris, c.1900
Colour process engraving, 32 x 25
Private collection
Illus. p. 52

96 Jean Auguste Dominique Ingres
(1780-1867)
Diploma for the Exhibition of 1855
Engraved by L. Calamatta, early
impression before plate was cut with
autograph, 59.2 x 76.6
The Trustees of the British Museum,
London

97 Janet-Lange (Ange-Louis Janet)
(1815-72)
France enlightening the World, 1848
Oil on canvas, 72.5 x 59
Musée Carnavalet, Paris

98 André Kertész (1894-1985)
Two little Breton girls
Cover photograph, VU, journal de la
semaine No.65, 5 June 1929,
38 x 27.5
Private collection

99 Yves Klein (1928-62)
Anthropométrie sans titre (ANT.23), 1960
Acrylic and drawing on paper,
94 x 56
Collection Jean-Yves Mock

100 Jean Emile Laboureur (1877-1943)
*An outdoor scene with a poetry reader and
a nude woman*, 1914
Etching, 37.4 x 45.7
The Trustees of the British Museum,
London
Illus. p. 126

101 Roger de La Fresnaye (1885-1925)
Seated Nude, c.1910
Enamelled ceramic,
42.5 x 30.5 x 19.3
Musée National d'Art Moderne,
Centre Georges Pompidou, Paris

102 Henri Laurens (1885-1954)
Caryatid, 1930
Bronze, 91 x 45 x 57
Musée National d'Art Moderne,
Centre Georges Pompidou, Paris

103 Fernand Léger (1881-1955)
Composition with Three Women, 1927*
Oil on canvas, 140 x 96
Musée d'Art Moderne,
St. Etienne

104 Fernand Léger
A Day in the Country, 1953
Oil on canvas, 130 x 160
Musée d'Art Moderne, St Etienne

105 Tamara de Lempicka (1898-1980)
Young Girl in Green, c.1927
Oil on plywood, 60.5 x 46
Musée National d'Art Moderne,
Centre Georges Pompidou, Paris
Illus. p. 114

106 Alfred Le Petit (1841-1909)
Checkmate
L'Eclipse, 15 October 1871
Coloured wood engraving, 50 x 33.5
Private collection

107 Evariste-Vital Luminais (1821-96)
Abduction of a Woman by Norsemen in the
ninth century, 1896
Oil on canvas, 189 x 114.4
Musée d'Art et d'Archéologie,
Moulins
Illus. p. 74

108 Aristide Maillol (1861-1944)
Draped Torso, c.1911
Bronze, 63 x 30
Musée des Beaux Arts, Dijon,
Donation Granville
Illus. p. 113

109 Albert Marquet, (1875-1947)
Nude, or Woman on a Divan, 1912
Oil on canvas, 100 x 81
Musée National d'Art Moderne,
Centre Georges Pompidou, Paris, gift
of Mme Druet
Illus. p. 124

110 Henri Matisse (1869-1954)
The Divan, 1921
Musée de l'Orangerie, Paris,
Collection Walter Guillaume
Illus. p. 119

111 Hugues Merle (1823-81)
A Beggar Woman, 1861
Oil on canvas, 110 x 81
Musée d'Orsay, Paris

112 Annette Messager (b.1943)
The Serial, episode 2, the Nightmare,
1977-8
Photograph on coloured card,
119 x 87
Lent by the artist

113 Lucien Marie François Métivet
(1863-1930)
Le peigne symbolique ou les idées de
derriére la tête d'une petite oie blanche.
(The symbolic comb, or the ideas in the back
of the head of a little white goose.)
From Le Rire, c.1900
Colour process engraving,
23.6 x 20.2
The Board of Trustees of the Victoria
and Albert Museum, London

114 Lucien Marie François Métivet
Cover, L'Album, no. XVI, 32 x 24.5
Paris, Jules Tallandier, c.1900
Private collection

115 Gustave Moreau (1826-98)
Salomé before Herod, c.1875
Oil on canvas, 92 x 60
Musée Gustave Moreau, Paris

116 François Paul Niclausse (1879-1958)
The Wet-nurse, 1912
Stone, 57 x 68 x 43
Musée Despiau-Wlérick, Mont-de-
Marsan, gift of Mme Landolt, 1972

117 Jean-Antoine Lecomte du Noüy
(1842-1923)
White Slave, 1888
Oil on canvas, 146 x 118
Musée des Beaux Arts, Nantes

118 Hermann-Paul (René Georges
Hermann Paul) (1864-1940)
Philemon et Baucis, 'Je parierais qu'il ne
m'a jamais trompée, cet idiot-la. . .'
(Philemon and Baucis, 'I would bet that
he's never been unfaithful, the idiot. . .')
Process engraving, for an
unidentified French periodical,
24.5 x 38.1
The Board of Trustees of the Victoria
and Albert Museum, London

119 Pablo Picasso (1881-1973)
Nu à mi-corps, 1923
Oil on canvas, 100 x 80
Musée National d'Art Moderne,
Centre Georges Pompidou, Paris
Illus. p. 116

120 Eugène Robert Poughéon
(1886-1955)
The Captives, c.1932
Oil on canvas, 120 x 120
Musée des Beaux Arts André
Malraux, Le Havre

121 Pierre Paul Prud'hon (1758-1823)
Minerva illuminating the Spirits of the Arts
and Sciences, c.1800
Oil on canvas, 25 x 29
Musée des Beaux Arts, Dijon

122 Pierre Puvis de Chavannes
(1824-98)
Portrait of Mme Puvis de Chavannes,
1883*
Oil on canvas, 78 x 46
Musée des Beaux Arts, Lyon
Illus. p. 104

123 Constant Puyo (1857-1933)
By the Fire, 1899
Oil transfer print, 22.4 x 16
Galerie Michel Chomette, Paris

124 Jean François Raffaëlli (1850-1924).
La Goulue, c.1880
Oil on canvas, 34.5 x 27
Musée des Beaux Arts, Dijon,
Donation Granville

125 Reiser
O.K., je suis toujours la plus belle
From Jeanine, published by Editions
Albin Michel SA
From drawings originally published
in Hara-Kiri, 1976-82
Collection Mme Reiser
Illus. p. 79

126 Rey
Cover photograph for Paris Match,
special issue,1988
Private collection

127 Théodule-Augustin Ribot (1823-91)
At the Sermon, 1890
Oil on canvas, 55 x 46
Musée d'Orsay, Paris

128 Denis Rivière (b. 1945)
Blue, White, Red, 1974
Oil on canvas, 97 x 130
Collection of the artist

129 Auguste Rodin (1840-1917)
La France, 1904
Bronze, 57 x 43
Musée Rodin, Paris

130 Auguste Rodin
Camille Claudel
Bronze, 24.5 x 15 x 18
Musée des Beaux Arts et de la
Dentelle, Calais

131 Jean Alphonse Roëhn (1799-1864)
'J'ai perdu!', 1824
('I've lost!')
Engraving by Chollet, printed by
Chardon, 51 x 37.5
The Trustees of the British Museum,
London
Illus. p. 28

132 Alfred Roll (1847-1919)
The Striker's Wife
Oil on canvas, 120 x 86
Musée Baron Martin, Gray

133 Willy Ronis (b.1910)
Provençal Nude: Marie-Anne at Gordes,
summer 1949
Silver print, 40 x 30
Collection of the artist
Illus. p. 82

134 Georges Rouault (1871-1958)
Fallen Eve (Nude at the mirror), 1905
Watercolour and pastel, 26.4 x 21.5
Musée d'Art Moderne de la Ville de
Paris

135 Georges Rouault
Nude, 1917
Mixed media, 31.5 x 25
Musée d'Art Moderne de la Ville de
Paris

136 Auguste Jean Baptiste Roubille
(1872-1955)
'Qui m'aime, m'essuie. . .'
('Whoever loves me, dries me. . .')
Colour process engraving,
19.2 x 27.2
The Board of Trustees of the Victoria
and Albert Museum, London

137 Auguste Jean Baptiste Roubille
'"Ta gueule!" s'écria Judith', c.1900
('"Hold your tongue!" cried Judith')
Colour process engraving,
28.8 x 45.9
The Board of Trustees of the Victoria
and Albert Museum, London

138 Edmond Adolphe Rudaux
Etude de paysage, 1871
Engraving by Levasseur, printed and
published by Goupil, 77.2 x 60
The Trustees of the British Museum,
London

139 Jean Rustin (b.1928)
Portrait of Madame S.
Oil on canvas, 130 x 162
Collection of the artist

140 Henry Scheffer (1798-1892)
The Arrest of Charlotte Corday, 1830
Engraved by Sixdeniers, printed by
Chardon Jeune and published by
Bulla Frères, Editeurs, 58.8 x 85
The Trustees of the British Museum,
London

141 Gaston Schnegg (1866-1953)
Portrait of Jeanne in a White Dress, 1914
Oil on canvas, 61 x 50
Musée des Beaux Arts, Bordeaux
Illus. p. 110

142 Louis Paul Henri Sérusier
(1864-1927)
Louise, or the Breton Servant Girl, 1890
Oil on canvas, 73 x 60
Musée départemental du Prieuré, St
Germain-en-Laye

143 Jean-Claude Servais (b.1956)
Illustrations from Tendre Violette:
Malmaison, published by Casterman,
1984
Collection Casterman
Illus. p. 78

144 Théophile Alexandre Steinlen
(1859-1923)
Plates from the set of 15 illustrating
Chansons de Femmes by Paul Delmet,
published by Enoch et Cie, Paris,
1899
1. Toujours vous, lithograph, 19 x 14.9
2. Chanson crépusculaire, lithograph,
 19 x 14.8
3. Une femme qui passe, lithograph,
 19.3 x 14.9
4. Chanson frêle, lithograph,
 20.1 x 16.2. Illus. p.54
The Board of Trustees of the Victoria
and Albert Museum, London

145 Théophile Alexandre Steinlen
'Elle etait si belle de loin. . . pendant la guerre.'
('She looked so fine from far away. . . during the war.')
Page from L'*Humanité*
30 April/1 May 1919
Zincograph and letterpress,
61 x 43.2
The Board of Trustees of the Victoria and Albert Museum, London

146 Théophile Alexandre Steinlen
While waiting, 1895
Lithograph, 37.4 x 25.8
The Board of Trustees of the Victoria and Albert Museum, London
Illus. p. 24

147 Théophile Alexandre Steinlen
Illustration to the song 'Feuilles mortes' by M. Boukay
From *Gil Blas Illustré, no.43*, 1895
Colour process engraving,
26.7 x 24.2
The Board of Trustees of the Victoria and Albert Museum, London

148 Ivan Theimer (b.1944)
Project for an Obelisk for the Elysée Palace, 1987
Tempera on paper, 38 x 36
Lent by the artist

149 Ivan Theimer
Project for an Obelisk, 1985
Tempera on paper, 30 x 26
Lent by the artist

150 Félix Edouard Vallotton (1865-1925)
Sunbathing on the Beach, 1923
Oil on canvas, 96 x 130
Musée des Beaux Arts et d'Archéologie, Rouen

151 Edouard Vuillard (1868-1940)
La couture, 1902-3
Oil on card, 28 x 31
Musée de la Ville de Poitiers et de la Societé des Antiquaires de l'Ouest

152 Robert Wlérick (1882-1944)
La Petite Landaise, 1911
Bronze, 40 x 31 x 17
Musée Despiau-Wlérick, Mont-de-Marsan

153 Anon
Woman aimed at by Prussian soldiers, c.1870
Oil on canvas, 27 x 21.5
Musée d'Orbigny-Bernon, La Rochelle

154 Anon
Woman showing a Wounded Soldier marks of Blood on the Wall, c.1870
Oil on canvas, 27 x 21.5
Musée d'Orbigny-Bernon, La Rochelle

155 Anon
Head of Marianne
Pressed metal relief, 28 x 20
Musée d'Orbigny-Bernon, La Rochelle

156 Anon
Head of Marianne
Wood relief, 26.5 x 18.5
Musée d'Orbigny-Bernon, La Rochelle

157 Image Populaire editée chez Le Fas Jean-Marie
Sainte-Marie, reine du ciel et de la terre (Holy Mary, Queen of heaven and earth)
Wood engraving with stencilled colouring, 87 x 79.5
Musée National des Arts et Traditions Populaires, Paris

158 Image populaire editée chez J. B. Faivre-Pierret (active to 1831)
Miraculous Image of Our Lady of Redemption
Coloured engraving, 63.5 x 47
Musée National des Arts et Traditions Populaires, Paris

159 Hara-Kiri No.2, 1988
28.5 x 22.5
Published by Editions des Trois Portes, Paris
Private collection

Bibliographical supplement

La Sculpture Française au XIX^e Siècle, exhibition catalogue, Grand Palais, Paris, 1986. A sumptuous account in thirteen chapters over 470 pages with details on such major commissions as those for the triumphal arches *du Carousel* and *de l'Etoile*.

Jeanne d'Arc et sa legende, exhibition catalogue, Musée des Beaux Arts de Tours, 1979. Notes on eighty items with supporting details.

Marie Claude Chaudonneret, *La Figure de la République. Le Concours de 1848, Notes et documents des musées de France, no.*13. Ministère de la Culture et de la Communication. Editions de la Réunion des musées nationaux, 1987. Sprightly research especially into the meaning of Daumier's *La République*, in the context of the national competition of 1848.

Le Triomphe des mairies. Grands décors républicains à Paris, 1870-1914, exhibition catalogue, Musée du Petit Palais, Paris, 1986-7. Notes and details on 282 items from twenty-eight *mairies*, on a range of civic and martial virtues, and on trading, schooling and family life.

Jean Starobinski, 1789. *Les Emblèmes de la Raison*, Flammarion, Paris, 1973 and 1979. Fifteen essays on such topics as the impoverishment of language in the Revolution; and much on Mozart and the meaning of *Don Giovanni*.

Artists' copyright and
Photographic credits

The publishers are grateful for permission to illustrate the work of artists whose copyright is represented by DACS.

DACS 1988: Arman, Balthus, Bernard, Bouchard, Brauner, Dupas, Gromaire, Léger, Lempicka, Maillol.

ADAGP: Paris/DACS London 1988: Bissière, Bonnard, Bourdelle, Braque, Laboureur, Marquet.

DACS 1988 and MAYA: Picasso.

Succession Henri Matisse/DACS 1988: Matisse.

Photographs have kindly been provided by lenders and by:

Cover illustration: © Dorothy Bohm

Agence Bulloz, Paris: Guérin
Camponogara, Lyon: Flandrin, Puvis de Chavannes
Giraudon, Paris: Amaury-Duval, Bernard, Chassériau
Agence Rapho, Paris: Doisneau, Ronis
Documentation Photographique de la Réunion des Musées Nationaux, Paris:
 Cottet, Couture, Delacroix, Flandrin, Géricault, Ingres
Musée de l'Affiche, Paris: Dupas
Musée des Beaux Arts, Nantes: Baudry
The National Gallery, London: Cézanne, Degas (reproduced by courtesy
 of the Trustees)
The Tate Gallery, London: Arman, Léger
The Wallace Collection, London: Papety (reproduced by permission of the Trustees)

Catalogue edited by Marianne Ryan
Designed by Archetype Design Associates
Printed in England by The Hillingdon Press, Uxbridge

A list of all South Bank Centre and Arts Council exhibition publications may be
obtained from the Publications Office, South Bank Centre, Royal Festival Hall,
London SE1 8XX.